Cool Restaurants
Chicago

teNeues

Imprint

Editor:	Michelle Galindo, Rose Lizarraga, Désirée von la Valette
Photos (location):	Doug Fogelson / DRFP (avec, Blackbird, N9NE / Ghost Bar), Tom Kozlowski (Boka), Tom Casey (crobar), Zeeshan Khan (L8), courtesy one sixtyblue & Tihany Design (one sixtyblue), courtesy Mirai (Mirai), courtesy International Hotels & Resorts, Mark Ballog, Steinkamp / Ballog Photography (Zest Restaurant). All other photos by Martin Nicholas Kunz & Michelle Galindo.
Introduction:	Rose Lizarraga
Layout & Pre-press:	Thomas Hausberg
Imaging:	Jan Hausberg
Map:	go4media. – Verlagsbüro, Stuttgart
Translations:	SAW Communications, Dr. Sabine A. Werner, Mainz Gemma Correa Buján (Spanish), Dr. Suzanne Kirkbright (English), Béatrice Nicolas-Ducreau (French), Elena Nobilini (Italian), Nina Hausberg (German / recipes)

Produced by fusion publishing GmbH, Stuttgart . Los Angeles
www.fusion-publishing.com

Published by teNeues Publishing Group

teNeues Publishing Company
16 West 22nd Street, New York, NY 10010, USA
Tel.: 001-212-627-9090, Fax: 001-212-627-9511

teNeues Book Division
Kaistraße 18, 40221 Düsseldorf, Germany
Tel.: 0049-(0)211-994597-0, Fax: 0049-(0)211-994597-40

teNeues Publishing UK Ltd.
P.O. Box 402, West Byfleet, KT14 7ZF, Great Britain
Tel.: 0044-1932-403509, Fax: 0044-1932-403514

teNeues France S.A.R.L.
4, rue de Valence, 75005 Paris, France
Tel.: 0033-1-55766205, Fax: 0033-1-55766419

www.teneues.com

ISBN: 3-8327-9018-7

© 2005 teNeues Verlag GmbH + Co. KG, Kempen

Printed in Germany

Bibliographic information published by Die Deutsche Bibliothek. Die Deutsche Bibliothek lists this publication in the Deutsche Nationalbibliografie; detailed bibliographic data is available in the Internet at http://dnb.ddb.de.

Contents

Page

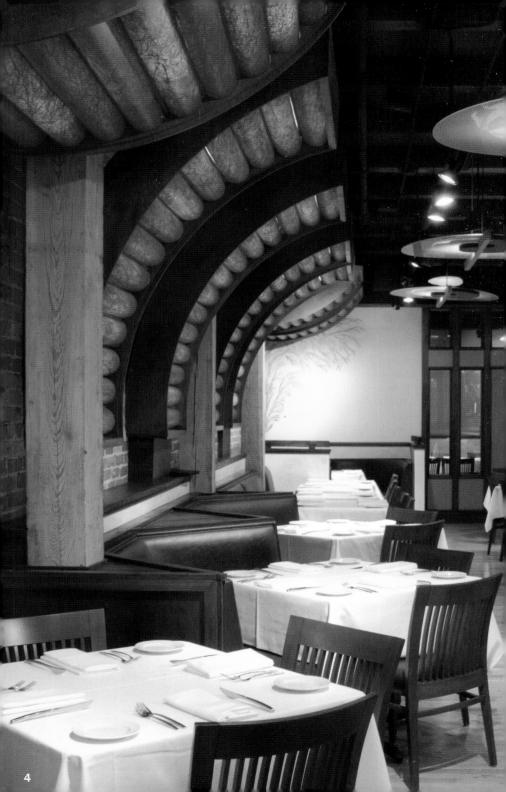

Introduction

Chicago's vast culinary landscape and unique architectural spaces have integrated themselves to regenerate the energy of the city. The restaurants in this selection respond moderately to their locations with a high degree of architectural integrity and distinctive theme districts. For decades the city has grown up on a steady diet of great architecture from such visionaries as Mies van der Rohe and Frank Lloyd Wright.

As the city has expanded, so has the local palate. Restaurateurs delving into innovative fusion concepts, re-invented ethnic cuisine and ever changing sushi culture have become urban pioneers, helping to develop the hippest neighborhoods from Bucktown to Wicker Park and the West Loop, and most recently, the South Loop, where the restaurants Opera and Saiko are located.

Each dining environment has successfully created its own culture and gastronomic experience intoxicating the city and people with elaborately elegant and starkly modern and original settings. High above the renowned boulevard "Magnificent Mile", Tony Chi, designer from NoMi, integrates inspiring views and sophisticated dining with Chicago's skyline, symbolizing the city's uplifting world of food and design.

Rose Lizarraga

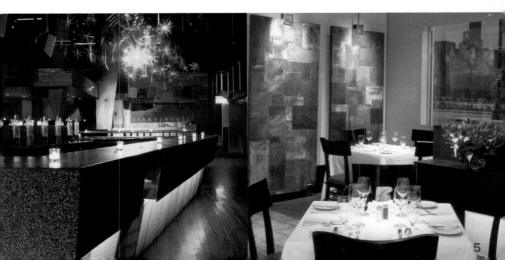

Einleitung

Chicagos vielfältige kulinarische Landschaft und die einzigartige Architektur ergän-
zen einander und haben die Energie dieser Stadt neu entfacht. Die Restaurants
aus der vorliegenden Auswahl fügen sich harmonisch in ihre Locations ein, die
geprägt sind durch ihre architektonische Tradition und die unverwechselbaren
Stadtteile unterschiedlichster Couleur. Jahrzehntelang wuchs diese Stadt unter der
Führung von großen Visionären wie Mies van der Rohe und Frank Lloyd Wright.

So wie die Stadt selbst hat sich auch der Geschmack ihrer Bewohner entwickelt
und erweitert. Innovativ verschmelzen Gastronomen verschiedene Konzepte. Die
sich neu erfindende ethnische Küche und die sich im ständigen Wandel befind-
liche Sushi-Kultur wurden zu urbanen Vorreitern und halfen, die angesagtesten
Gegenden zwischen Bucktown, Wicker Park und West Loop – und in jüngster Zeit
South Loop, wo sich die Restaurants Opera und Saiko befinden – voranzubringen.

Jedes dieser kulinarischen Viertel hat sich mit Erfolg eine eigene Kultur geschaf-
fen, Gastronomieerfahrung gesammelt und begeistert mit raffiniert-eleganten,
ultramodernen und originellen Lokalen. Hoch oben über dem renommierten Bou-
levard „Magnificent Mile" rundet der NoMi-Designer Tony Chi anregende Ausblicke
und feinste Esskultur mit Chicagos Skyline ab, die zum Sinnbild für die aufstreben-
de Restaurant- und Design-Szene dieser Stadt wird.

Rose Lizarraga

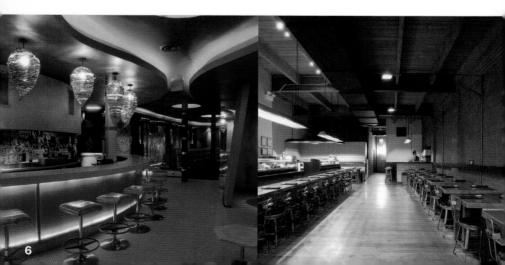

Introduction

La grande variété du paysage culinaire de Chicago et les espaces architectoniques uniques se sont complétés pour donner à la ville une nouvelle énergie. Les restaurants présentés ici s'intègrent harmonieusement dans leurs espaces et avec beaucoup de sensibilité dans l'architecture des différents quartiers, qui possèdent chacun des caractères bien distincts. L'architecture de cette ville s'est développée pendant des décennies sous l'influence de grands visionnaires comme Mies van der Rohe et Frank Lloyd Wright.

Le goût de ses habitants s'est développé avec la même exigence que l'évolution ambitieuse de la ville. Les restaurateurs mêlent différents concepts de manière innovatrice. La cuisine ethnique réinventée et la culture des sushis en perpétuelle évolution sont devenues des pionniers urbains et ont contribué au développement des quartiers les plus en vogue entre Bucktown, Wicker Park et West Loop – et plus récemment South Loop, où se trouvent les restaurants Opera et Saiko.

Chaque lieu de dégustation a réussi à créer sa propre culture, à accumuler des expériences gastronomiques et à séduire la ville et les gens avec des espaces d'une élégance raffinée, ultramodernes et originaux. En haut, au dessus du boulevard renommé de « Magnificent Mile », Tony Chi, le designer de NoMi a conjugué vues excitantes et dîners fins avec la skyline de Chicago, qui est devenu le symbole du monde ambitieux de la gastronomie et du design de la ville.

Rose Lizarraga

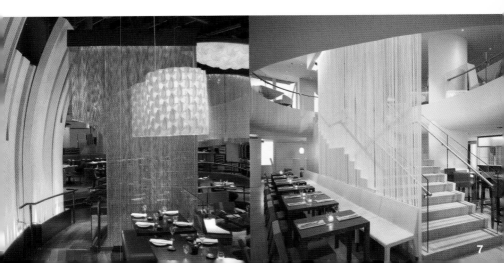

Introducción

El variado paisaje culinario de Chicago y la excepcional arquitectura se complementan mutuamente y han desplegado de nuevo la energía de esta ciudad. Los restaurantes de la presente selección se adaptan armónicamente a sus emplazamientos, marcados por su tradición arquitectónica y los inconfundibles barrios del más diferente carácter. Durante decenios, esta ciudad creció bajo el liderazgo de grandes visionarios como Mies van der Rohe und Frank Lloyd Wright.

Como la ciudad misma, también el gusto de sus habitantes se ha desarrollado y ampliado. Los gastrónomos fusionan diferentes conceptos de forma innovadora. La cocina étnica que se está reinventando y la cultura del sushi, que se halla en un cambio continuo, se convirtieron en precursoras urbanas y ayudaron a fomentar las zonas de más furor entre Bucktown, Wicker Park y West Loop y, recientemente, South Loop donde se encuentran los restaurantes Opera y Saiko.

Cada uno de estos barrios culinarios se ha creado con éxito una cultura propia, ha reunido experiencia gastronómica y entusiasma con locales refinados, ultramodernos y originales. Arriba en lo alto del famoso boulevard "Magnificent Mile" el diseñador del NoMi, Tony Chi, completa unas vistas excitantes y la cultura gastronómica más elegante con la skyline de Chicago que se convierte en el símbolo de la floreciente movida de restaurantes y diseño de esta ciudad.

Rose Lizarraga

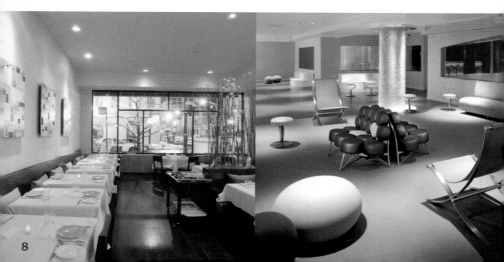

Introduzione

Il vasto panorama culinario di Chicago e i singolari spazi architettonici si completano vicendevolmente e hanno ridato nuova energia a questa città. I ristoranti presentati in questa selezione s'inseriscono armoniosamente nei propri spazi, caratterizzati da un'accentuata integrità architettonica e da caratteristici quartieri. Per decenni la città crebbe sotto la guida di grandi visionari quali Mies van der Rohe e Frank Lloyd Wright.

All'espandersi della città anche il gusto dei suoi abitanti si è fatto più esigente. In modo innovativo i gastronomi fondono concetti diversi. La cucina etnica reinventata e la cultura del sushi in continuo cambiamento sono diventate pionieri urbani e hanno contribuito allo sviluppo delle zone più alla moda, da Bucktown a Wicker Park e West Loop, e, più recentemente, South Loop, dove si trovano i ristoranti Opera e Saiko.

Ogni quartiere culinario si è creato con successo una propria cultura e ha raccolto esperienza gastronomica, entusiasmando con ambienti di una raffinata eleganza, ultramoderni e originali. E lassù in alto, sul celebre viale "Magnificent Mile", Tony Chi, il designer di NoMi, è riuscito a completare un suggestivo panorama e pasti raffinati con lo sfondo dello skyline di Chicago, simbolo della scena culinaria e del design in continua ascesa di questa città.

Rose Lizarraga

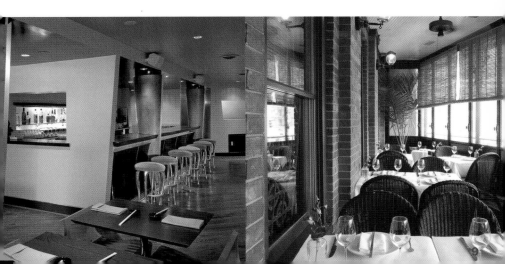

avec

Design: Thomas Schlesser | Executive Chef: Paul Kahan, Chef de
Cusine: Koren Grieveson | Owners: Donald J. Madia, Paul Kahan,
Eduard Seitan, Rick Diarmit

615 West Randolph Street | Chicago, IL 60606
Phone: +1 312 377 2002
www.avecrestaurant.com
Opening hours: Mon–Thu 3:30 pm to midnight, Fri–Sat 3:30 pm to 1 am,
Sun 3:30 pm to 10 pm
Average price: $ 30
Cuisine: Country French, Italian, Portuguese and Spanish
Special features: Cedar-lined dining wine bar

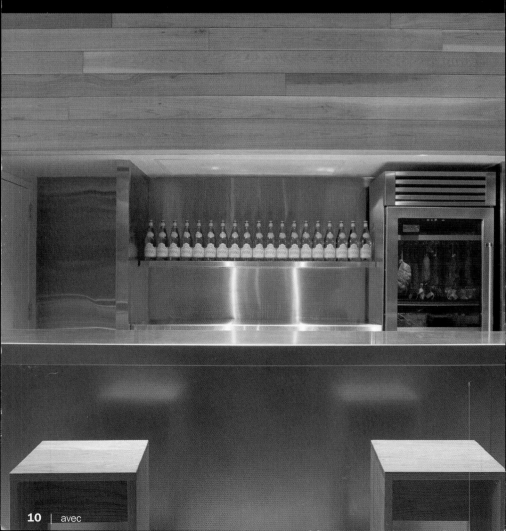

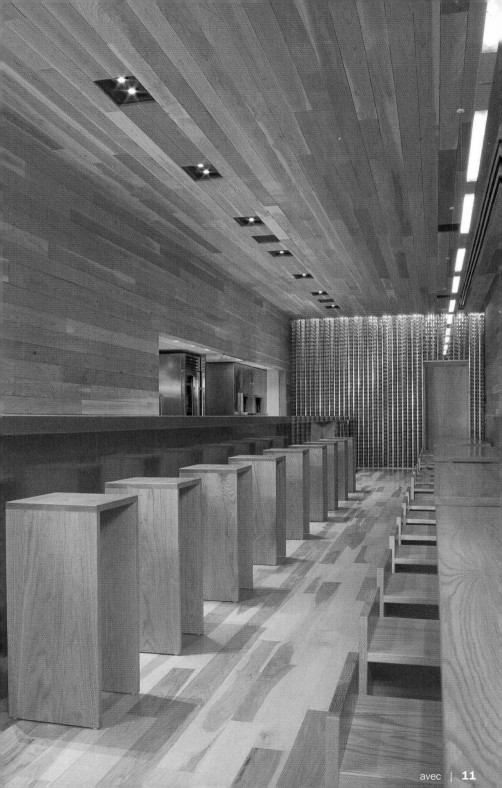

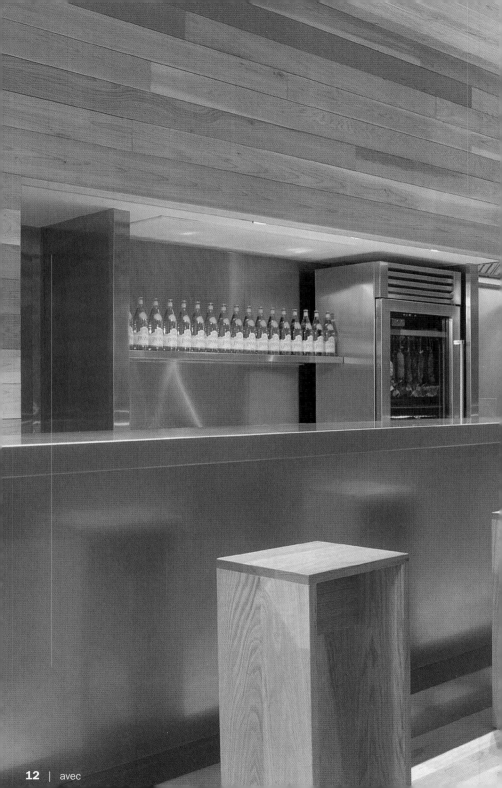

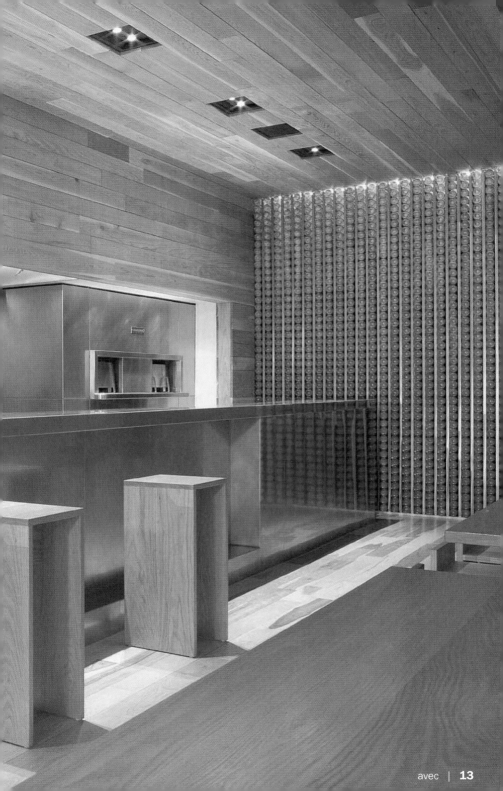

Blackbird

Design: Thomas Schlesser | Executive Chef: Paul Kahan
Owners: Donald J. Madia, Paul Kahan, Eduard Seitan, Rick Diarmit

619 West Randolph Street | Chicago, IL 60606
Phone: +1 312 715 0708
www.blackbirdrestaurant.com
Opening hours: Mon–Fri 11:30 am to 2:00 pm, Mon–Thu 5:30 pm to 10:30 pm,
Fri–Sat 5:30 pm to 11:30 pm
Average price: $ 40
Cuisine: American
Special features: Trendy scene, inspired cuisine and notable wine list

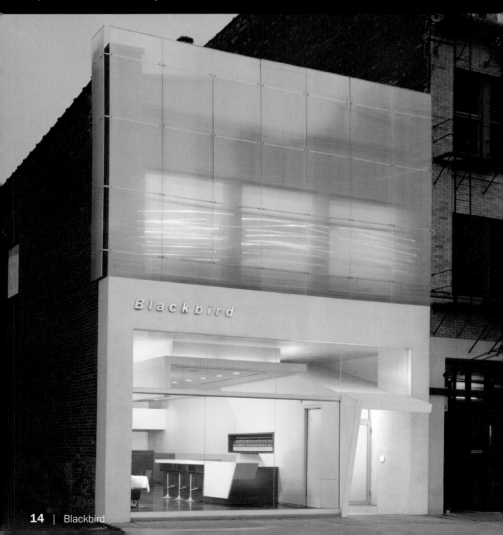

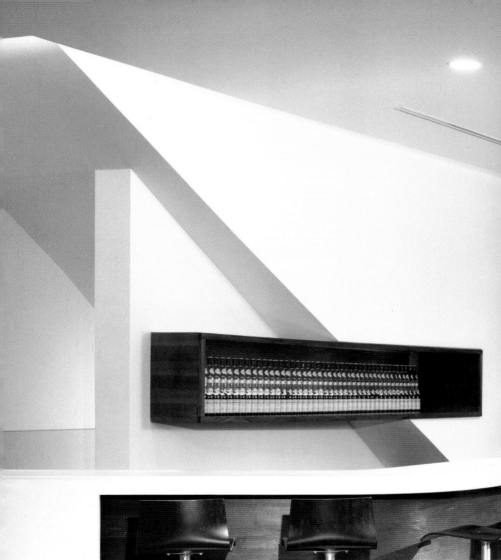

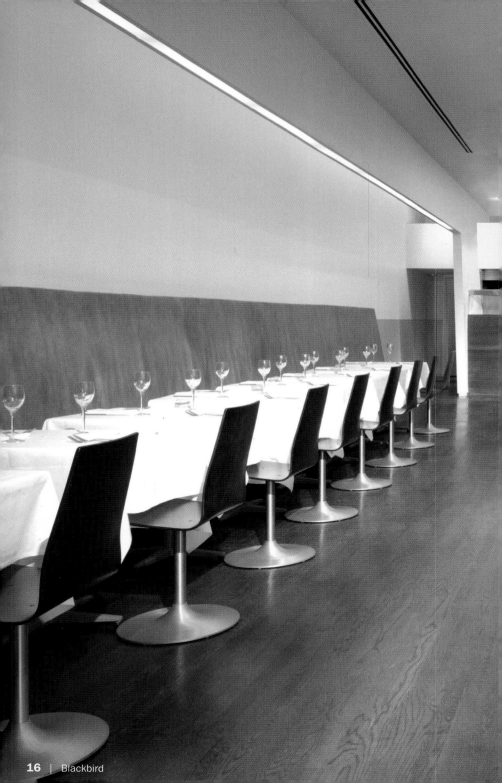

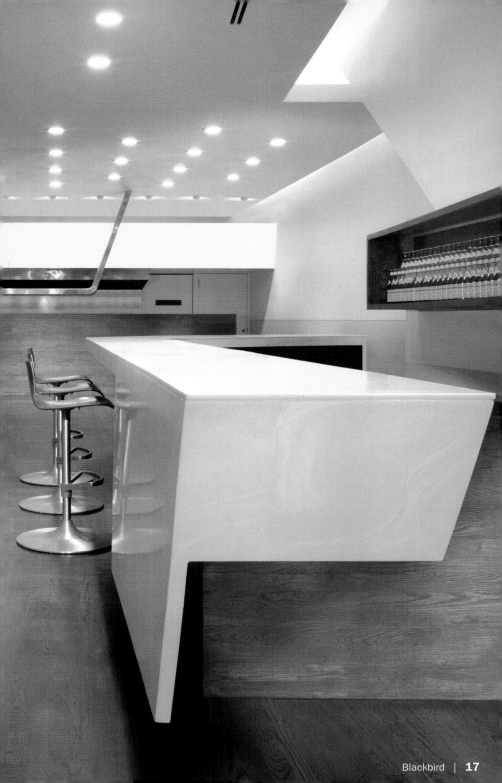

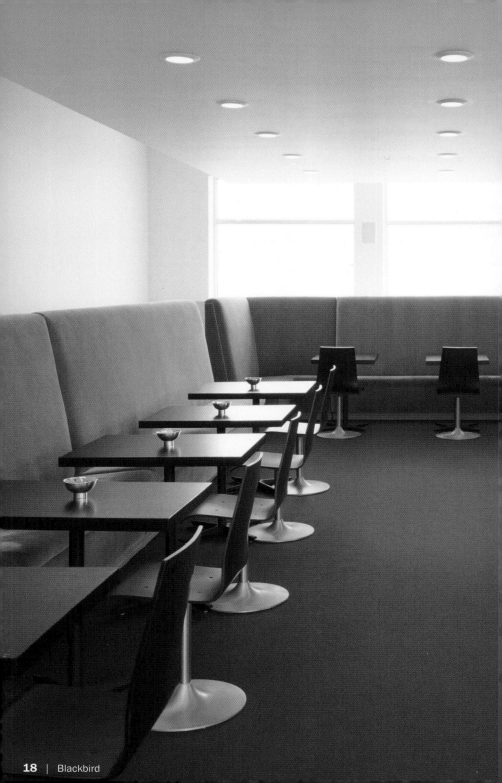

Braised Belly of Pork

Geschmorter Schweinebauch

Poitrine de porc en cocotte

Panza de cerdo asada

Pancetta di maiale stufata

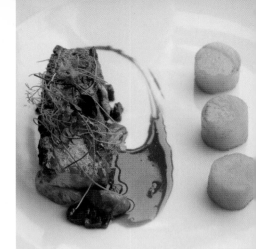

1 lb belly of pork, about 2 lb 3 oz
1 tbsp grape-seed oil
1 tbsp coriander seeds, roasted
1 tbsp fennel seeds, roasted
1 tbsp cumin, roasted
8 cloves chopped garlic
1 diced onion
2 celery roots, diced
2 carrots, diced
240 ml white wine
500 ml chicken stock
1 sprig of thyme
Salt and pepper

Remove all the fat from the meat the evening beforehand but leave a layer of about 0.5 in. covering the meat. Roughly chop the spices, blend with oil and garlic and spread on the upper and underside of the meat. Store in the refrigerator. Next day, scrape off the spices from the fatty side and season the meat with salt and pepper. Pre-heat a heavy sauce pan at medium heat and add the meat, fatty side down. When the fat is browned, transfer the meat to a second, roasting pan, fatty side up. Drain most of the fat from the first pan, add the vegetables, brown lightly and add to the meat. Pour in the wine, chicken stock and add thyme, salt and pepper. Set the meat, uncovered, in an oven at 325 °F and braise for 2–3 hours, or until tender. Remove the meat and divide into 4 portions, fry until crisp on the fatty side and keep warm. Drain off the meat juices and pour through a sieve. Serve with a bean ragout and brussel sprouts.

1 Schweinebauch, ca. 1 kg
1 EL Traubenkernöl
1 EL Koriandersamen, geröstet
1 EL Fenchelsamen, geröstet
1 EL Kreuzkümmel, geröstet
8 Knoblauchzehen, gehackt
1 Zwiebel, gewürfelt
2 Sellerie, gewürfelt
2 Karotten, gewürfelt
240 ml Weißwein
500 ml Geflügelbrühe
1 Zweig Thymian
Salz, Pfeffer

Am Abend vorher alles Fett bis auf einen 1 cm breiten Rand wegschneiden. Gewürze grob mahlen und mit Öl und Knoblauch vermischt auf die Ober- und Unterseite des Bauches streichen. In den Kühlschrank legen. Am nächsten Tag Gewürze von der Fettseite kratzen, salzen und pfeffern. Eine schwere Pfanne bei mittlerer Flamme erhitzen und das Fleisch mit der Fettseite nach unten hineinlegen. Wenn das Fett gebräunt ist, Fleisch in eine Fettpfanne mit der Fettseite nach oben legen. Das meiste Fett aus der ersten Pfanne abgießen, Gemüse hinzufügen, anschwitzen und dann dem Fleisch beimischen. Wein, Geflügelbrühe und Thymian hinzugeben und mit Salz und Pfeffer würzen. Unbedeckt in einen 160 °C heißen Ofen geben und für 2–3 Stunden, bzw. bis das Fleisch weich ist, garen lassen. Fleisch herausnehmen, in 4 Stücke teilen, auf der Fettseite noch einmal kross anbraten und warm stellen. Das Fett von der Schmorflüssigkeit entfernen und diese durch ein Sieb gießen. Mit Bohnenragout und Rosenkohl servieren.

1 poitrine de porc d'environ 1 kg
1 c. à soupe d'huile de pépins de raisin
1 c. à soupe de graines de coriandre grillées
1 c. à soupe de graines de fenouil grillées
1 c. à soupe de graines de cumin grillées
8 gousses d'ail hachées
1 oignon coupé en dés
2 céleris coupés en dés
2 carottes coupées en dés
240 ml de vin blanc
500 ml de bouillon de volaille
1 branche de thym
Sel, poivre

La veille, préparer la viande en enlevant la graisse de façon à n'en laisser que 1 cm, moudre grossièrement les épices et les mélanger avec l'huile et l'ail. Badigeonner la viande des deux cotés avec ce mélange. La mettre au réfrigérateur. Le lendemain, gratter la viande du coté de la graisse pour enlever les épices, saler et poivrer. Mettre à chauffer une poêle à fond épais sur feu modéré et y poser la viande, le coté gras vers le fond. Quand la graisse est devenue dorée, mettre la viande dans une lèchefrite, le côté graisse vers le haut. Jeter la plus grande partie de la graisse de la première poêle, y faire revenir les légumes et ensuite les ajouter à la viande. Mouiller avec le vin et le bouillon de volaille, ajouter le thym, sel et poivre. Mettre au four à 160 °C sans couvrir et laisser cuire pendant 2 à 3 heures, jusqu'à ce que la viande soit tendre. Sortir le morceau de viande, le couper en quatre. Le faire revenir encore du côté de la graisse pour qu'il soit croustillant, le tenir au chaud. Dégraisser le jus de cuisson et le passer. Servir avec des haricots ou des choux de Bruxelles.

1 panza de cerdo, aprox. 1 kg
1 cucharada de aceite de pepitas de uva
1 cucharada de semillas de cilantro, tostadas
1 cucharada de semillas de hinojo, tostadas
1 cucharada de comino, tostado
8 dientes de ajo, picados
1 cebolla, en cuadraditos
2 apios, en cuadraditos
2 zanahorias, en cuadraditos
240 ml de vino blanco
500 ml de caldo de ave
1 rama de tomillo
Sal, pimienta

La noche anterior cortar toda la grasa excepto un borde de 1 cm. Moler las especias a granos gruesos y, mezclados con aceite y ajo, untar la parte superior y la inferior de la panza. Poner en la nevera. Al día siguiente, rascar las especias de la parte de la grasa, poner sal y pimienta. Calentar una sartén grande a fuego mediano y colocar dentro la carne con la parte de la grasa hacia abajo. Cuando la grasa esté dorada, poner la carne con la parte de la grasa hacia arriba en otra sartén. Verter la mayoría de la grasa de la primera sartén, añadir la verdura, dorar y mezclar entonces a la carne. Añadir el vino, el caldo de ave y el tomillo y aliñar con sal y pimienta. Poner destapado en un horno a 160 °C y asar durante 2-3 horas, o bien hasta que la carne esté blanda. Sacar la carne, cortar en 4 pedazos, sofreír otra vez por la parte de la grasa hasta que esté bien hecha y mantener caliente. Quitar la grasa del líquido del asado y verter por un colador. Servir con ragout de judías y coles de Bruselas.

1 pancetta di maiale da 1 kg circa
1 cucchiaio di olio di vinacciolo
1 cucchiaio di semi di coriandolo tostati
1 cucchiaio di semi di finocchio tostati
1 cucchiaio di cumino tostato
8 spicchi d'aglio tritati
1 cipolla tagliata a dadini
2 sedani tagliati a dadini
2 carote tagliate a dadini
240 ml di vino bianco
500 ml di brodo di pollo
1 rametto di timo
Sale, pepe

La sera prima tagliate via quasi tutto il grasso lasciando solo un margine di 1 cm. Macinate le spezie grosse, mescolatele all'olio e all'aglio e spalmatele sulla parte superiore e inferiore della pancetta. Mettete in frigorifero. Il giorno dopo raschiate via le spezie dalla parte di grasso, salate e pepate. Riscaldate una padella pesante a fuoco medio e mettetevi dentro la carne con la parte di grasso rivolta verso il basso. Non appena il grasso sarà rosolato, mettete la carne in una leccarda con la parte di grasso rivolta verso l'alto. Scolate quasi tutto il grasso dalla prima padella, aggiungete la verdura, fatela dorare e mescolatela quindi alla carne. Aggiungete il vino, il brodo di pollo e il timo, salate e pepate. Passate in forno caldo a 160 °C senza coprire e fate cuocere per 2–3 ore finché la carne sarà tenera. Togliete la carne, dividetela in 4 pezzi, fatela rosolare di nuovo sulla parte di grasso fino a renderla croccante e mettete in caldo. Togliete il grasso dal liquido dello stufato e passate il liquido in un colino. Servite con ragù di fagioli e cavolini di Bruxelles.

Boka

Design: Warren Ashworth of Bogdanow Partners
Chef: Giuseppe Scurato | Owners: Rob Katz, Kevin Boehm

1729 North Halsted | Chicago, IL 60614
Phone: +1 312 337 6070
www.bokachicago.com
Opening hours: Daily 5 pm to 11 pm, bar open Sun–Fri until 2 am, Sat 3 am
Average price: $ 25
Cuisine: American new
Special features: Theater district dining

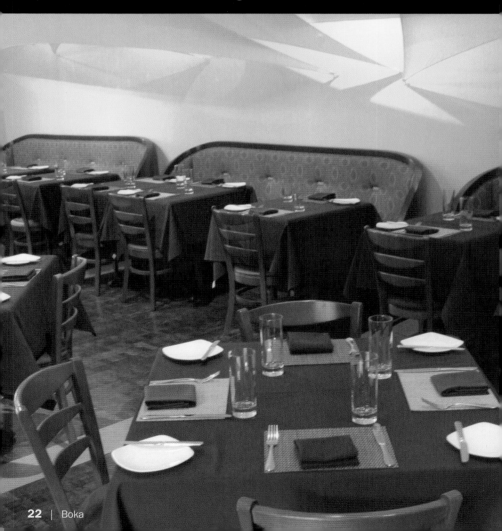

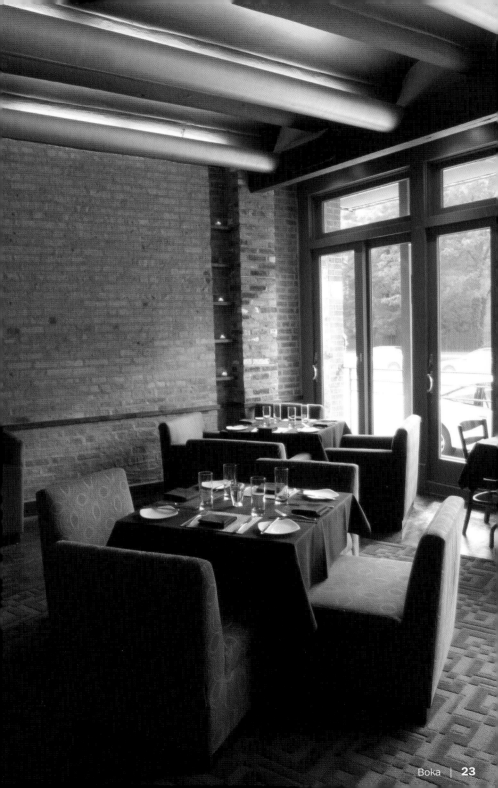

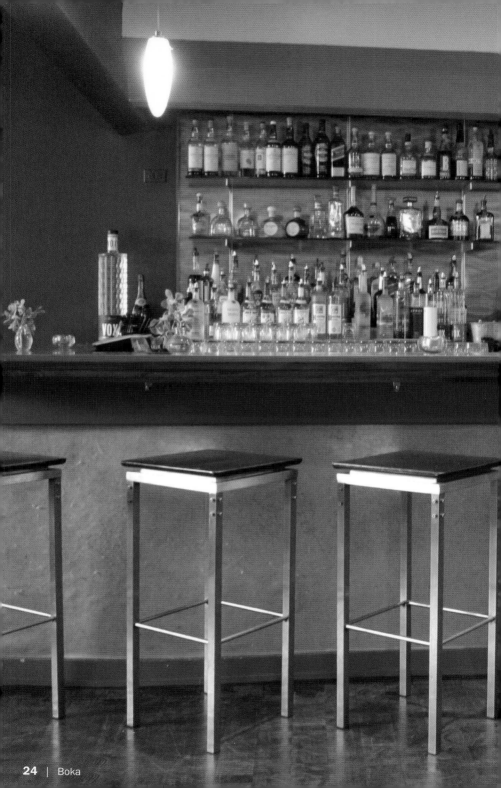

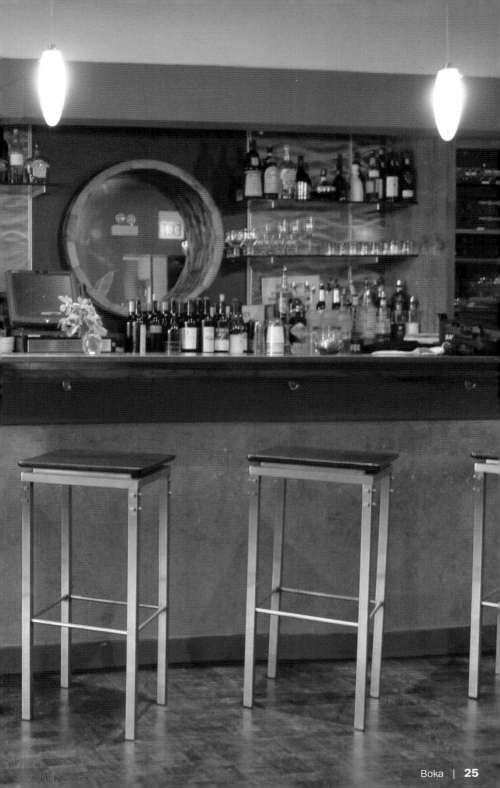

Café des Architectes
& Le Bar at the Sofitel

Design: Pierre-Yves Rochon | Chef: Frederic Castan

20 East Chestnut Street | Chicago, IL 60611
Phone: +1 312 324 4000
www.sofitel-chicago-watertower.com
Opening hours: Daily 6 am to 10:30 pm, Le Bar daily 3 pm to 1 am
Average price: $ 30
Cuisine: French
Special features: Stylish, upscale hotel dining

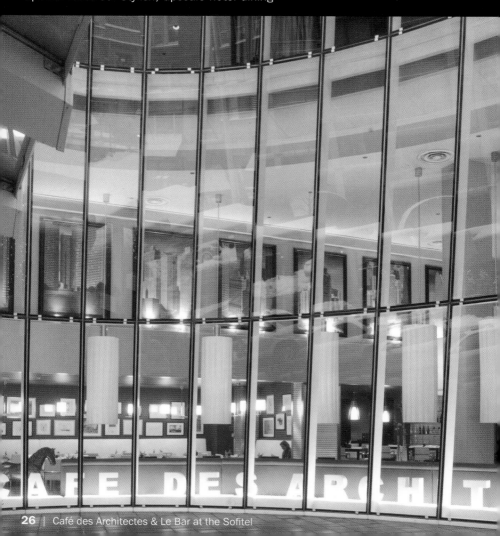

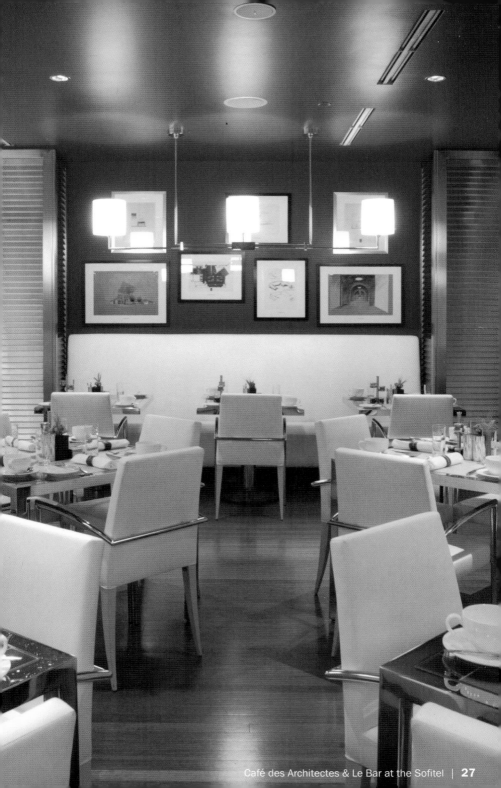

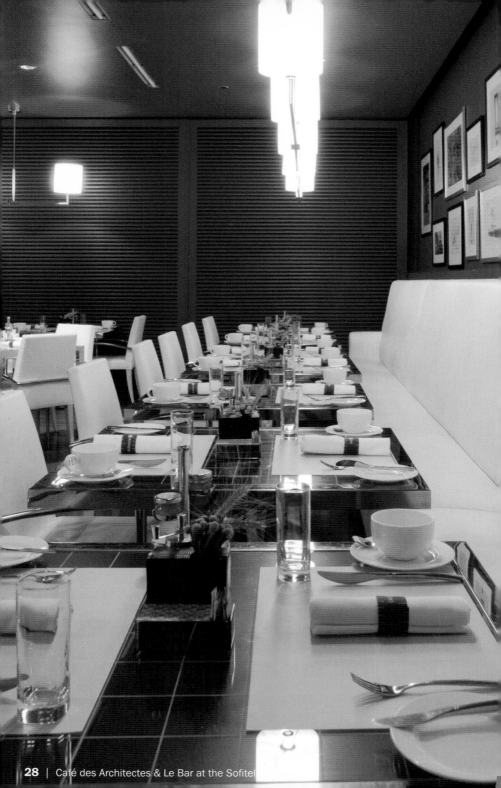

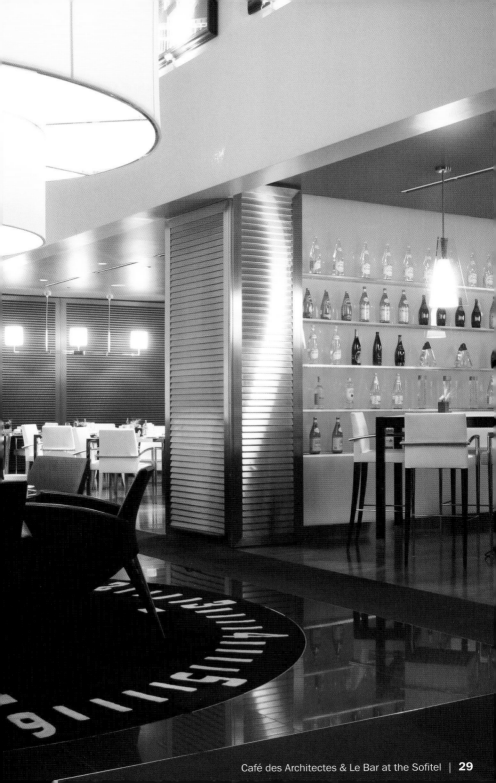

crobar

Design: Callin Fortis Bigtime Design, Lionel Ohayon Icrave Design

1543 North Kingsbury Street | Chicago, IL 60622
Phone: +1 312 266 1900
www.crobar.com
Opening hours: Fri–Sun 10 pm to 4 am, Sat 10 pm to 5 am
Special features: Dance floor, VIP room

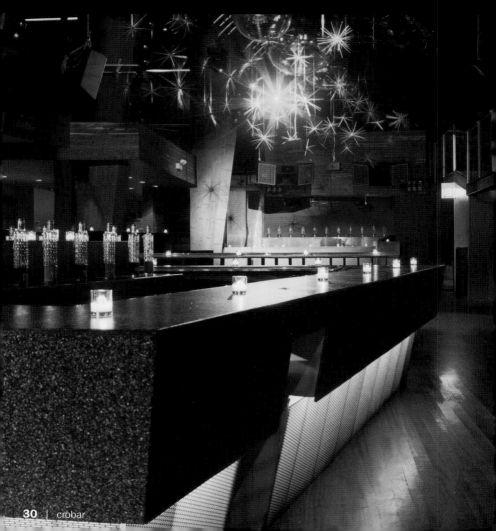

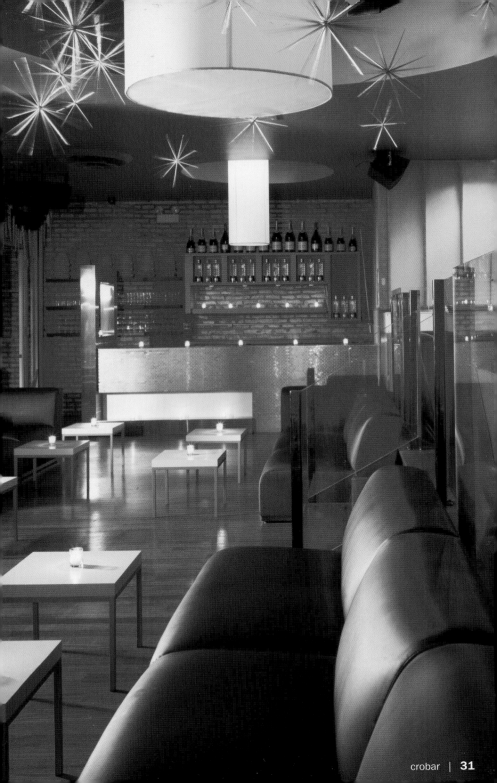

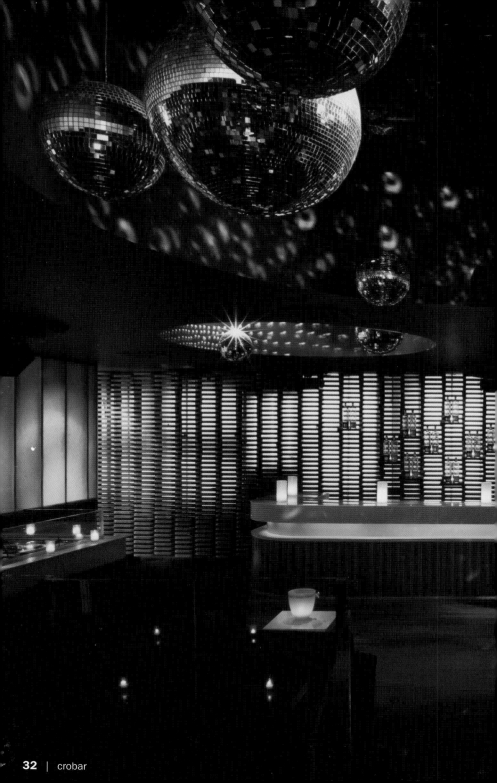

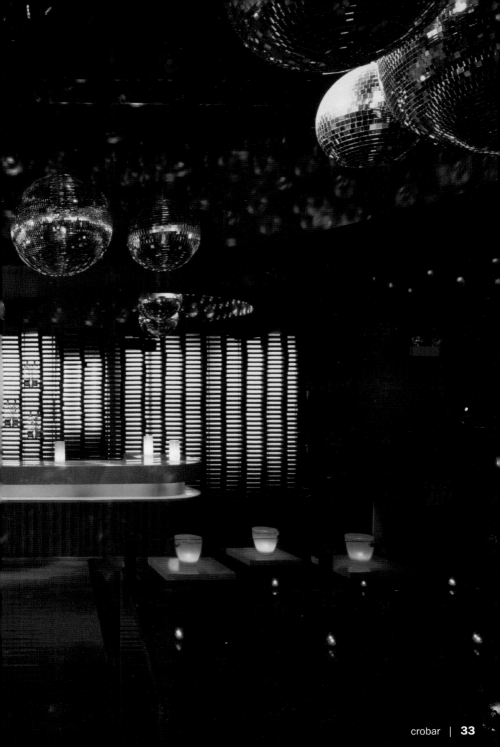

Design: Amelia Hepler-Briske | Chef: Jill Barron-Rosenthal
Owners: Angela M. Hepler, Susan Traina Thompson

814 West Randolph Street | Chicago, IL 60607
Phone: +1 312 455 8114
www.decerotaqueria.com
Opening hours: Mon–Fri 11:30 am to 2 pm, Mon–Thu: 5 pm to 10 pm,
Fri–Sat 5 pm to 11 pm
Average price: $ 10
Cuisine: Fresh Mexican

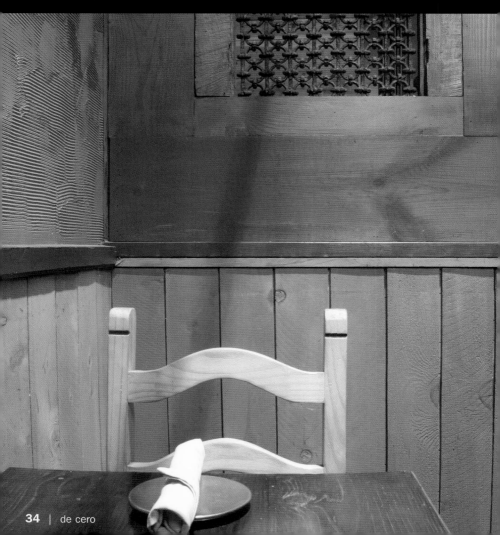

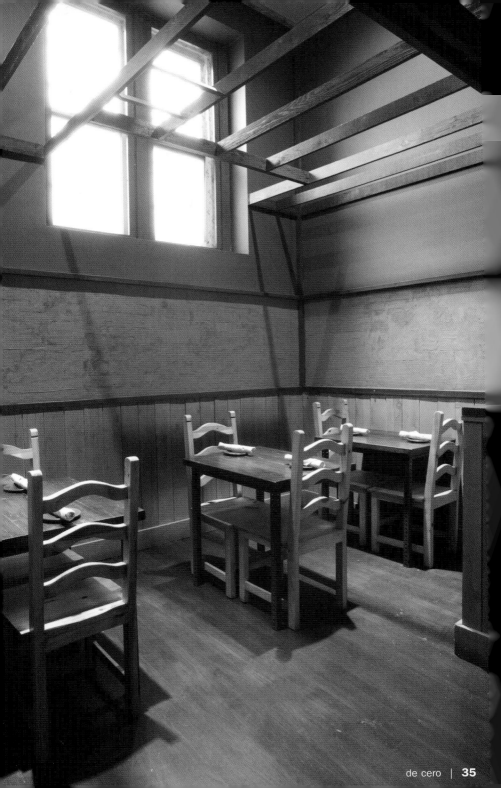

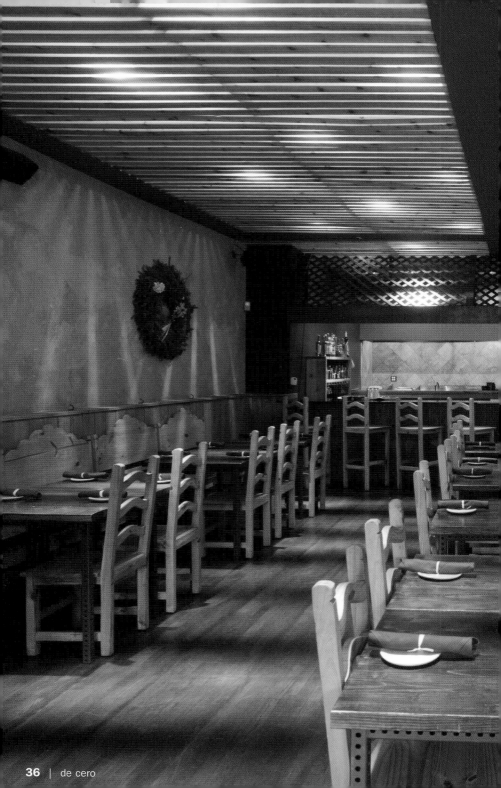

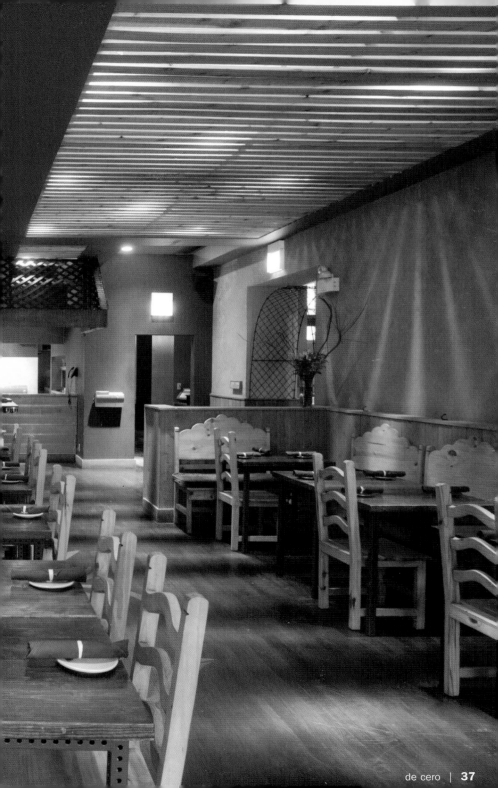

Tuna Fish Tacos

Tunfisch-Tacos

Tacos de thon

Tacos de atún

Taco al tonno

Salsa:
1 mango, peeled and diced
1 red pepper, cleaned and diced
4 tbsp diced, red onions
1 small Habanero chili, diced
1 tsp chopped coriander
Juice of one lime
2 tbsp olive oil
Salt and pepper

Mix all the ingredients and set aside.

8 ½ oz tuna fish
Olive oil, salt and pepper
4 corn tortillas

Rub the olive oil, salt and pepper on the tuna fish and grill for 2 minutes on both sides. Cut into small pieces and keep warm. Heat 4 corn tortillas, fill with the salsa and tuna fish. Serve immediately.

Salsa:
1 Mango, geschält und gewürfelt
1 rote Paprika, geputzt und gewürfelt
4 EL rote Zwiebel, gewürfelt
1 kleine Habanero-Chilischote, gewürfelt
1 TL Koriander, gehackt
Saft einer Limette
2 EL Olivenöl
Salz, Pfeffer

Alle Zutaten mischen, beiseite stellen.

240 g Tunfisch
Olivenöl, Salz, Pfeffer
4 Mais-Tortillas

Den Tunfisch mit Olivenöl, Salz und Pfeffer einreiben und auf jeder Seite 2 Minuten grillen. In kleine Stücke schneiden und warm stellen. 4 Mais-Tortillas erwärmen, mit der Salsa und dem Tunfisch füllen und sofort servieren.

Sauce :
1 mangue, épluchée et coupée en dés
1 poivron rouge, nettoyé et coupé en dés
4 c. à soupe d'oignon rouge coupé en dés
1 petit piment de la Havane coupé en dés
1 c. à café de coriandre hachée
Le jus d'une limette
2 c. à soupe d'huile d'olive
Sel, poivre

Mélanger les ingrédients, réserver.

240 g de thon
Huile d'olive, sel, poivre
4 tortillas de maïs

Badigeonner le thon avec le mélange huile, sel et poivre et le faire griller des deux côtés. Le couper en petits morceaux et le garder au chaud. Chauffer quatre tortillas de maïs, les farcir avec la sauce et le thon et servir aussitôt.

Salsa:
1 mango, pelado y en cuadraditos
1 pimiento rojo, limpio y en cuadraditos
4 cucharadas de cebolla roja, en cuadraditos
1 chile habanero pequeño, en cuadraditos
1 cucharadita de cilantro, picado
El zumo de una lima
2 cucharadas de aceite de oliva
Sal, pimienta

Mezclar todos los ingredientes, poner aparte.

240 g de atún
Aceite de oliva, sal, pimienta
4 tortillas de maíz

Untar el atún con aceite de oliva, sal y pimienta y asar a la parrilla por cada lado durante 2 minutos. Cortar en trozos pequeños y mantener caliente. Calentar 4 tortillas de maíz, rellenar con la salsa y el atún y servir inmediatamente.

Salsa:
1 mango sbucciato e tagliato a dadini
1 peperone rosso privato dei semi e tagliato a dadini
4 cucchiai di cipolla rossa tagliata a dadini
1 peperoncino habanero piccolo tagliato a dadini
1 cucchiaino di coriandolo tritato
Succo di una limetta
2 cucchiai di olio d'oliva
Sale, pepe

Mescolate tutti gli ingredienti e metteteli da parte.

240 g di tonno
Olio d'oliva, sale, pepe
4 tortilla di mais

Fregate il tonno con l'olio d'oliva, il sale e il pepe e grigliatelo per 2 minuti per lato. Tagliatelo a pezzetti e mettetelo in caldo. Riscaldate 4 tortilla di mais, farcitele con la salsa e il tonno e servitele subito.

Follia Restaurant

Design: Melissa Abate, Bruno Abate | Chef: Bruno Abate
Owners: Melissa Abate, Bruno Abate

953 West Fulton Market | Chicago, IL 60607
Phone: +1 312 243 2888
www.folliachicago.com
Opening hours: Mon–Thu 5 pm to 11 pm, Fri–Sat 5 pm to 1 am
Average price: $ 30
Cuisine: Contemporary authentic Italian
Special features: Hip crowd, late night dining

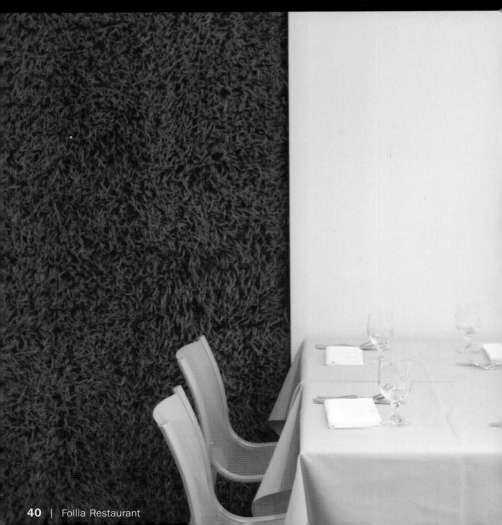

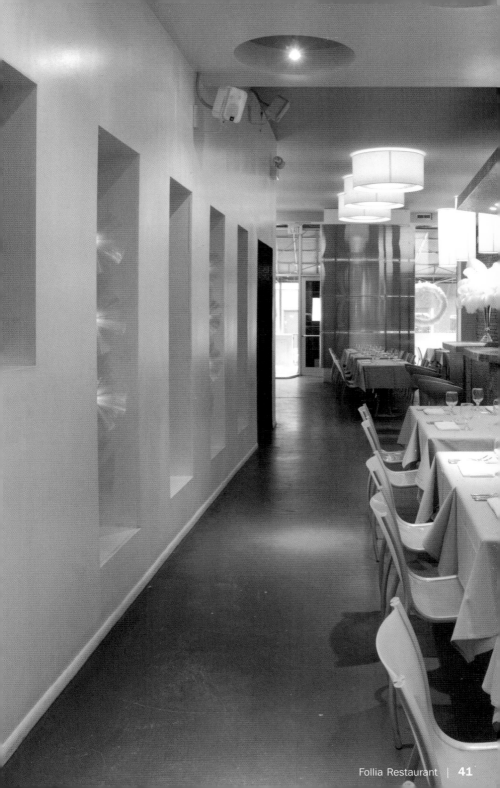

Four Seasons Pizza

Pizza Vier Jahreszeiten

Pizza des quatre saisons

Pizza Cuatro estaciones

Pizza Quattro stagioni

Pizza Base:
1 lb flour
Pinch of salt
2 oz yeast
180 ml warm water
3 tbsp olive oil

Mix all ingredients in a large bowl, leave in a warm place for 30 minutes and allow the dough to rise. Kneed to a soft dough. Set aside.

Pizza Sauce:
1 can of peeled, chopped tomatoes
2 tsp olive oil
2–3 fresh basil leaves
1 tsp of salt
A pinch of oregano
A pinch of coarse-ground pepper

Mix all ingredients in a bowl and set aside.

Topping:
Mozzarella
Artichokes
Sliced mushrooms
Parma ham

Divide the dough into 4 pieces, roll out to a diameter of about 14 in. Cover the dough evenly with 3 tbsps of pizza sauce. Sprinkle a topping of your choice on the pizza. Set to bake in a preheated oven at 360 °F for 8–10 minutes.

Pizzateig:
500 g Mehl
Prise Salz
60 g Hefe
180 ml warmes Wasser
3 EL Olivenöl

Alle Zutaten in einer großen Schüssel mischen, an einem warmen Ort 30 Minuten gehen lassen. Zu einem weichen Teig verkneten. Beiseite stellen.

Pizzasauce:
1 Dose geschälte, gestückelte Tomaten
2 TL Olivenöl
2–3 frische Basilikumblätter
1 TL Salz
Prise Oregano

Prise groben Pfeffer

Alle Zutaten in einer Schüssel mischen und beiseite stellen.

Belag:
Mozzarella
Artischocken
Pilze in Scheiben
Parmaschinken

Den Teig in vier Stücke teilen, zu einem Durchmesser von ca. 36 cm ausrollen. 3 EL Pizzasauce gleichmäßig auf dem Teig verteilen. Belag nach Belieben auf der Pizza verteilen. Bei 180 °C im vorgeheizten Ofen 8–10 Minuten backen.

Pâte à pizza :
500 g de farine
Une pincée de sel
60 g de levure de boulanger
180 ml d'eau tiède
3 c. à soupe d'huile d'olive

Mélanger tous les ingrédients dans une grande terrine, laisser reposer dans un endroit chaud pendant 30 minutes. Pétrir jusqu'à l'obtention d'une pâte molle. Mettre de côté.

Pour la sauce à pizza :
1 boîte de tomates pelées et coupées en morceaux
2 c. à café d'huile d'olive
2–3 feuilles de basilic fraîches
1 c. à café de sel

Une pincée d'origan
Une pincée de poivre concassé

Mettre tous les ingrédients dans une terrine et réserver.

Pour la garniture :
Mozzarelle
Artichauts
Champignons émincés
Jambon de parme

Partager la pâte en quatre, l'abaisser pour former un cercle d'environ 36 cm de diamètre. Etaler régulièrement 3 cuillères de sauce sur la pâte. Répartir la garniture selon son goût sur la pâte. Mettre à cuire pendant 8 à 10 minutes dans le four préchauffé à 180 °C.

Masa de la pizza:
500 g de harina
Una pizca de sal
60 g de levadura
180 ml de agua caliente
3 cucharadas de aceite de oliva

Mezclar todos los ingredientes en una fuente grande, dejar reposar en un lugar caliente durante 30 minutos. Amasar una pasta blanda. Poner aparte.

Salsa para la pizza:
1 lata de tomates pelados y troceados
2 cucharaditas de aceite de oliva
2–3 hojas de albahaca fresca
1 cucharadita de sal
Una pizca de orégano
Una pizca de pimienta gruesa

Mezclar todos los ingredientes en una fuente y ponerlos aparte.

Cobertura:
Mozzarella
Alcachofas
Setas a rodajas
Jamón de Parma

Dividir la masa en 4 partes, extenderla con el rodillo hasta un diámetro de 36 cm aprox. Repartir uniformemente 3 cucharadas de salsa para la pizza sobre la masa. Repartir sobre la pizza los ingredientes para la cobertura según el gusto. Cocer a 180 °C en el horno precalentado durante 8-10 minutos.

Impasto per la pizza:
500 g di farina
Pizzico di sale
60 g di lievito
180 ml di acqua calda
3 cucchiai di olio d'oliva

In una ciotola capiente mescolate tutti gli ingredienti e lasciateli lievitare per 30 minuti in un luogo caldo. Lavorate ancora gli ingredienti fino ad ottenere una pasta morbida. Mettete da parte.

Salsa per la pizza:
1 barattolo di pomodori pelati tagliati a pezzetti
2 cucchiaini di olio d'oliva
2–3 foglie di basilico fresco
1 cucchiaino di sale

Pizzico di origano
Pizzico di pepe grosso

Mescolate tutti gli ingredienti in una ciotola e metteteli da parte.

Farcitura:
Mozzarella
Carciofi
Funghi a fette
Prosciutto di Parma

Dividete l'impasto in 4 parti, spianatelo fino ad ottenere un diametro di 36 cm. Distribuite uniformemente sull'impasto 3 cucchiai di salsa per la pizza. Distribuite a piacere la farcitura sulla pizza. Cuocete per 8–10 minuti in forno preriscaldato a 180 °C.

Japonais

Design: Jeffrey Beers International | Chef: Jun Ichikawa, Gene Kato

600 West Chicago Avenue | Chicago, IL 60610
Phone: +1 312 822 9600
www.japonaischicago.com
Opening hours: Mon–Fri 11:30 am to 2:30 pm, Mon–Thu 5 pm to 11 pm,
Fri–Sat 5 pm to 11:30 pm, Sun 5 pm to 10 pm, lounge open Sun–Wed until 1 am,
Thu–Fri 2 am, Sat 3 am
Average price: Appetizers $ 4 – $ 24, entrees $ 19 – $ 35
Cuisine: Contemporary Japanese
Special features: Subterranean lounge, fireplace, waterfront terrace, a sensuous scene

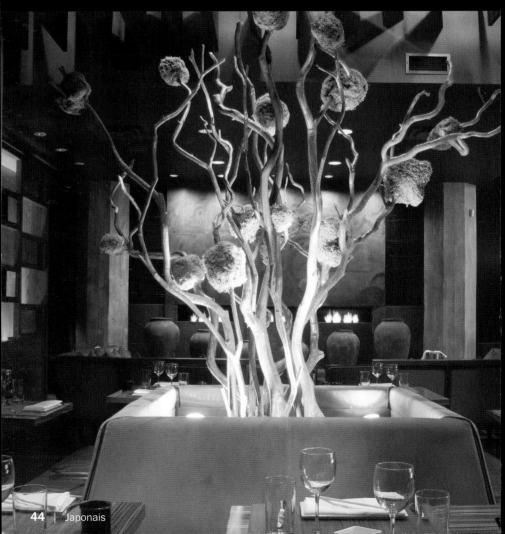

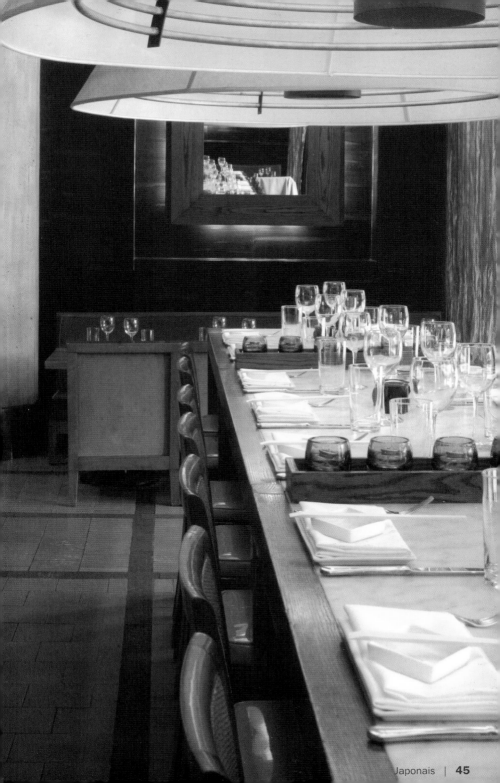

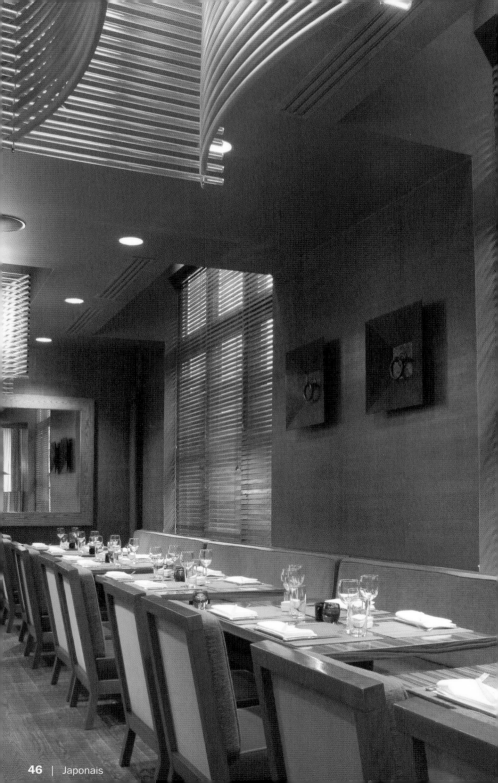

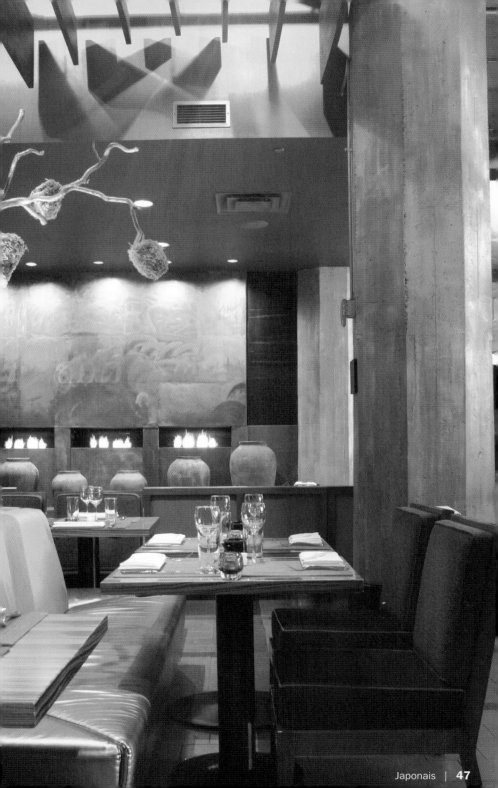

Four Samurais

Vier Samurai

Quatre samouraïs

Cuatro samurais

Quattro samurai

Squid Tartar:
6 1/2 oz squid
2 tbsp Rayu (chili oil)
2 tbsp spring onions, chopped
2 tbsp Tobiko (flying fish roe)
3 tbsp Kewpie mayonnaise

Shrimp Tartar:
6 1/2 oz shrimp flesh
2 tbsp chives
2 tsp sesame oil
1 tsp chopped garlic
Prawn head (for decoration)

Scallop Tartar:
6 1/2 oz scallop flesh
1 tbsp curry powder
Juice of one lime
3 tbsp cucumber, grated
3 tbsp Kewpie mayonnaise

2 tbsp chives
1 tbsp ginger
Salt and pepper
Black Tobiko roe (for decoration)

Lobster Tartar:
6 1/2 oz lobster flesh
2 oz Edam cheese
6 Ohba leaves (Japanese mint)
1 diced mango
1 chopped orange
2 tbsp Kewpie mayonnaise
Orange and lemon rind as decoration

Mix the ingredients separately for each tartar sauce. Arrange the tartar on the dishes and garnish with suitable decoration for each sauce. Serve with Wan-Tan Chips.

Tintenfisch-Tartar:
180 g Tintenfisch
2 EL Rayu (Chiliöl)
2 EL Frühlingszwiebel, gehackt
2 EL Tobiko (Fliegenfischrogen)
3 EL Kewpie-Mayonnaise

Shrimps-Tartar:
180 g Shrimpsfleisch
2 EL Schnittlauch
2 TL Sesamöl
1 TL Knoblauch, gehackt
Garnelenkopf (Dekoration)

Kammmuschel-Tartar:
180 g Kammmuschelfleisch
1 EL Currypulver
Saft einer Limette
3 EL Gurke, geraspelt

3 EL Kewpie-Mayonnaise
2 EL Schnittlauch
1 EL Ingwer
Salz, Pfeffer
Schwarzer Tobiko (Dekoration)

Hummer-Tartar
180 g Hummerfleisch
60 g Edamer
6 Ohbablätter (japanisches Minzblatt)
1 Mango, gewürfelt
1 Orange, gehackt
2 EL Kewpie-Mayonnaise
Orangen-und Zitronenschale (Dekoration)

Die Zutaten für jeden Tartar getrennt mischen. Tartar auf Teller geben und mit der jeweilig passenden Dekoration verzieren. Mit Wan-Tan-Chips servieren.

Tartare de seiche :
180 g de seiche
2 c. à soupe de rayu (huile de piment)
2 c. à soupe d'oignon de printemps haché
2 c. à soupe de tobiko (caviar de poisson volant)
3 c. à soupe de mayonnaise Kewpie

Tartare de crevettes :
180 g chair de crevettes
2 c. à soupe de ciboulette
2 c. à café d'huile de sésame
1 c. à café d'ail hachée
Tête de crevette pour la décoration

Tartare de coquilles Saint-Jacques :
180 g de chair de coquilles Saint-Jacques
1 c. à soupe de poudre de curry
Le jus d'une limette
3 c. à soupe de concombre râpé

3 c. à soupe de mayonnaise Kewpie
2 c. à soupe de ciboulette
1 c. à soupe de gingembre
Sel, poivre
Tobiko noir (pour la décoration)

Tartare de homard :
180 g de chair de homard
60 g d'Edamer
6 feuilles de ohba (menthe japonaise)
1 mangue coupée en dés
1 orange hachée
2 c. à soupe de mayonnaise Kewpie
Zestes d'orange et de citron pour la décoration

Mélanger séparément les ingrédients des différents tartares. Les mettre sur des assiettes et ajouter la décoration qui convient. Servir avec des chips Wan-Tan.

Tartar de pulpo:
180 g de pulpo
2 cucharadas de Rayu (aceite de chile)
2 cucharadas de cebolleta, picadas
2 cucharadas de Tobiko (huevas de pez volador)
3 cucharadas de mayonesa Kewpie

Tartar de gambas:
180 g de carne de gambas
2 cucharadas de cebollino
2 cucharaditas de aceite de sésamo
1 cucharadita de ajos, picados
La cabeza de un camarón (decoración)

Tartar de pechina venera:
180 g de carne de pechina venera
1 cucharada de polvo de curry
El zumo de una lima
3 cucharadas de pepino, rallado
3 cucharadas de mayonesa Kewpie

2 cucharadas de cebollino
1 cucharada de jengibre
Sal, pimienta
Tobiko negro (decoración)

Tartar de langosta
180 g de carne de langosta
60 g de Edamer
6 hojas de Ohba (hoja de la menta japonesa)
1 mango, en cuadraditos
1 naranja, picada
2 cucharadas de mayonesa Kewpie
Cáscara de naranja y de limón (decoración)

Mezclar los ingredientes para cada tartar por separado. Poner el tartar en platos y adornar con la correspondiente decoración apropiada. Servir con Wan Tan.

Tartara di calamari:
180 g di calamari
2 cucchiai di Rayu (olio al peperoncino)
2 cucchiai di cipollotto tritato
2 cucchiai di tobiko (uova di pesce volante)
3 cucchiai di maionese Kewpie

Tartara di gamberetti:
180 g di polpa di gamberetti
2 cucchiai di erba cipollina
2 cucchiaini di olio di sesamo
1 cucchiaino di aglio tritato
Testa di gamberi (per decorare)

Tartara di canestrelli:
180 g di polpa di canestrelli
1 cucchiaio di polvere di curry
Succo di una limetta
3 cucchiai di cetriolo grattugiato

3 cucchiai di maionese Kewpie
2 cucchiai di erba cipollina
1 cucchiaio di zenzero
Sale, pepe
Tobiko nero (per decorare)

Tartara di astice:
180 g di polpa di astice
60 g di Edamer
6 foglie di ohba (foglia di menta giapponese)
1 mango tagliato a dadini
1 arancia tritata
2 cucchiai di maionese Kewpie
Scorza di arancia e limone (per decorare)

Mescolate per ogni tartara i rispettivi ingredienti. Disponete la tartara sul piatto e decorate con la rispettiva decorazione. Servite con chips di wan tan.

Kevin Restaurant

Design: Nancy Warren | Chef: Kevin Shikami
Owners: Alan Shikami, Kevin Shikami

9 West Hubbard Street | Chicago, IL 60610
Phone: +1 312 595 0055
www.kevinrestaurant.com
Opening hours: Mon–Fri 11:30 am to 2 pm, Mon–Thu 5:30 pm to 10 pm,
Fri–Sat 5:30 pm to 11 pm
Average price: $ 30
Cuisine: Asian-European
Special features: Private room, daily changing menu, patio dining during summer

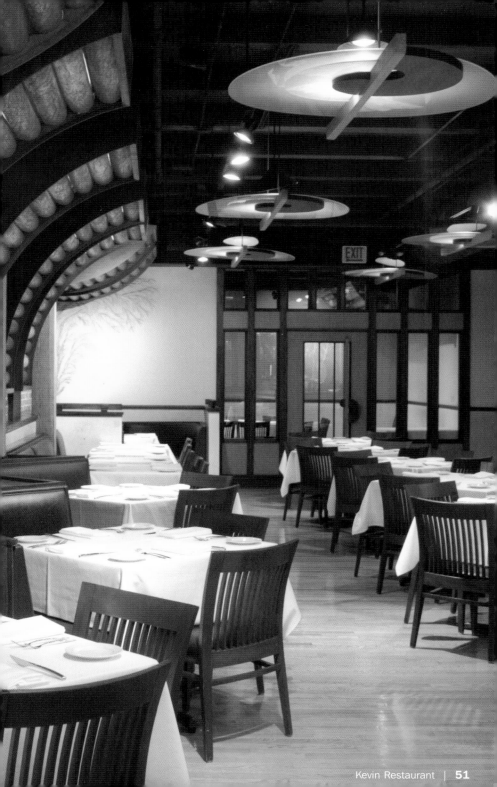

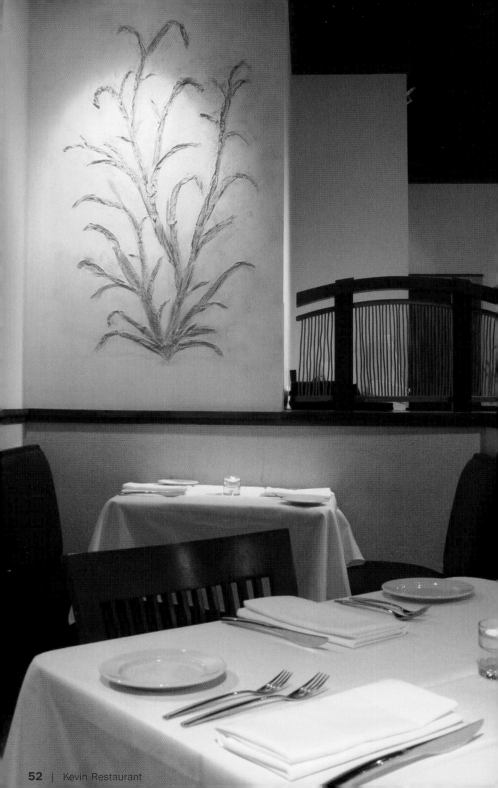

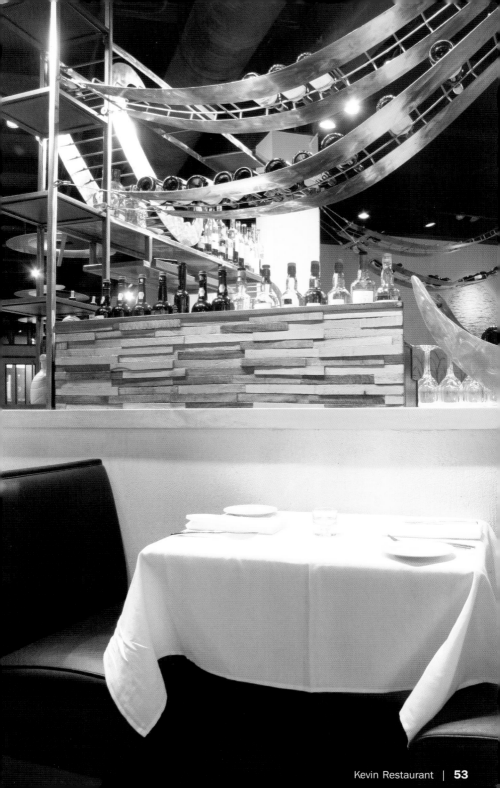

Sushi Risotto
with Lobster and White Truffle

Sushi-Risotto mit Hummer und
weißem Trüffel

Riz sushi au homard et à la truffe blanche

Risotto de Sushi con langosta y trufa blanca

Risotto sushi con astice e tartufo bianco

3 oz sushi rice
3 tbsp sushi vinegar
2 lobsters
1 tbsp vegetable oil
1 diced onion
300 ml white wine
240 ml water
2 carrots, finely diced
7 tbsp chives, chopped
Grape-seed oil
3 tbsp butter
1 tsp ginger, chopped
2 oz bean sprouts
60 ml chicken stock
Salt and pepper
1 white truffle

Follow the instructions on the packet to prepare the rice, allow to cool and mix with the vinegar. Blanch the lobster in boiling, salted water. Cook for 6 minutes and allow to cool. Remove the flesh from the shell and cut into bite-size pieces. Keep the shell. Heat the oil in a large pot, add the onions and lobster shell and steam for 5 minutes. Pour in the white wine and water and bring to the boil. Reduce the liquid down to about 2 cups. Remove the liquid and set aside. Blanch the diced carrots in salted water until "al dente". Blanch 4 tbsp of chives, drain and purée with the grape-seed oil. Melt 2 tbsp of butter in a pan at medium heat, add the carrots, 3 tbsp of chives and ginger. Cook for 1 minute, then add the lobster flesh, sushi rice and bean sprouts. Heat the chicken stock in a small saucepan with 1 tbsp of butter and mix the chive purée into the stock, season with salt and pepper. Arrange the risotto on a dish, drizzle with the chive stock and decorate with white truffle.

90 g Sushi-Reis
3 EL Sushi-Essig
2 Hummer
1 EL Pflanzenöl
1 Zwiebel, gewürfelt
300 ml Weißwein
240 ml Wasser
2 Karotten, fein gewürfelt
7 EL Schnittlauch, gehackt
Traubenkernöl
3 EL Butter
1 TL Ingwer, gehackt
60 g Erbsentriebe
60 ml Geflügelbrühe
Salz, Pfeffer
1 weißer Trüffel

Den Reis nach Packungsanweisung zubereiten, abkühlen lassen und mit dem Essig vermischen. Hummer in kochendem Salzwasser blanchieren. Für 6 Minuten kochen lassen, abkühlen. Das Fleisch aus dem Panzer lösen und in mundgerechte Stücke schneiden. Panzer aufbewaren. Das Öl in einem großen Topf erhitzen, die Zwiebeln und die Hummerpanzer hineingeben und für 5 Minuten dünsten. Weißwein und Wasser einmischen und aufkochen lassen. Die Flüssigkeit auf ca. 2 Tassen reduzieren. Abseihen und beiseite stellen. Karottenwürfel in Salzwasser bissfest blanchieren. 4 EL Schnittlauch blanchieren, abgießen und mit dem Traubenkernöl pürieren. 2 EL Butter bei mittlerer Hitze in einer Pfanne schmelzen lassen, Karotten, 3 EL Schnittlauch und Ingwer dazugeben. 1 Minute kochen, dann Hummerfleisch, Sushi-Reis und Erbsentriebe untermischen. In einem kleinen Topf die Geflügelbrühe erhitzen, mit 1 EL Butter und Schnittlauchpüree zu Fond mischen und mit Salz und Pfeffer abschmecken. Das Risotto auf einen Teller geben, mit dem Schnittlauchfond beträufeln und mit weißem Trüffel dekorieren.

90 g de riz à sushi
3 c. à soupe de vinaigre pour sushi
2 homards
1 c. d'huile végétale
1 oignon coupé en dés
300 ml de vin blanc
240 ml d'eau
2 carottes coupées en petits dés
7 c. à soupe de ciboulette hachée
Huile de pépins de raisin
3 c. à soupe de beurre
1 c. à café de gingembre haché
60 g de pousses de petits pois
60 ml de bouillon de volaille
Sel, poivre
1 truffe blanche
Cuire le riz selon les indications sur l'emballage, le laisser refroidir et y mélanger le vinaigre. Blanchir les homards dans de l'eau bouillante salée. Cuire pendant 6 minutes,

faire refroidir. Décortiquer le homard et couper la chair en morceaux de la taille d'une bouchée. Réserver les carapaces. Mettre l'huile à chauffer dans une poêle, ajouter l'oignon et la chair de homard et faire revenir pendant 5 minutes. Verser le vin et l'eau et laisser cuire jusqu'à ce qu'il n'y ait plus qu'environ 2 tasses de liquide. Egoutter et réserver. Blanchir les dés de carottes dans de l'eau salée de façon à ce qu'ils restent fermes. Blanchir 4 c. à soupe de ciboulette, égoutter, réduire en purée en ajoutant l'huile de pépins de raisin. Faire fondre à feu modéré 2 c. à soupe de beurre dans une poêle, y ajouter les carottes, 3 c. de ciboulette et le gingembre. Laisser cuire 1 minute et y ajouter en mélangeant la chair de homard, le riz à sushi et les pousses de pois. Chauffer le bouillon de volaille dans une petite casserole, y mélanger 1 c. à soupe de beurre et la purée de ciboulette pour faire un fond. Saler et poivrer. Disposer le risotto sur une assiette, verser quelques gouttes de fond de ciboulette sur le dessus et décorer avec la truffe blanche.

90 g de arroz de Sushi
3 cucharadas de vinagre de Sushi
2 langostas
1 cucharada de aceite vegetal
1 cebolla, en cuadraditos
300 ml de vino blanco
240 ml de agua
2 zanahorias, en cuadraditos finos
7 cucharadas de cebollino, picado
Aceite de pepitas de uva
3 cucharadas de mantequilla
1 cucharadita de jengibre, picado
60 g de brotes de guisantes
60 ml de caldo de ave
Sal, pimienta
1 trufa blanca
Preparar el arroz según las indicaciones del paquete, dejar enfriar y mezclar con el vinagre. Escaldar la langosta en agua hirviendo con sal. Dejar cocer durante 6 minutos, enfriar. Desprender la carne del caparazón y cortar a trozos pequeños. Guardar los caparazones.

Calentar el aceite en una olla grande, poner dentro las cebollas y los caparazones de las langostas y rehogar durante 5 minutos. Mezclar el vino blanco y el agua y dar un hervor. Rebajar el líquido a 2 tazas. Colar y poner aparte. Escaldar los cuadraditos de zanahorias en agua con sal hasta que estén a punto. Escaldar 4 cucharadas de cebollino, verter y hacer puré con el aceite de pepitas de uva. Derretir 2 cucharadas de mantequilla en una sartén a fuego mediano, añadir las zanahorias, 3 cucharadas de cebollino y el jengibre. Cocer durante 1 minuto, entonces entremezclar la carne de langosta, el arroz de Sushi y los brotes de guisantes. Calentar el caldo de ave en una olla pequeña, mezclar con 1 cucharada de mantequilla y el puré de cebollino hasta hacer un caldo concentrado y sazonar con sal y pimienta. Poner el risotto en un plato, rociar con el caldo concentrado de cebollino y decorar con trufa blanca.

90 g di riso per sushi
3 cucchiai di aceto per sushi
2 astici
1 cucchiaio di olio vegetale
1 cipolla tagliata a dadini
300 ml di vino bianco
240 ml di acqua
2 carote tagliate a dadini sottili
7 cucchiai di erba cipollina tritata
Olio di vinacciolo
3 cucchiai di burro
1 cucchiaino di zenzero tritato
60 g di germogli di piselli
60 ml di brodo di pollo
Sale, pepe
1 tartufo bianco
Preparate il riso come indicato sulla confezione, lasciatelo raffreddare e mescolatelo con l'aceto. Sbollentate gli astici in acqua salata bollente. Lasciate cuocere per 6 minuti, fate raffreddare.

Staccate la polpa dalla corazza e tagliate a bocconcini. Conservate le corazze. In un tegame grande riscaldate l'olio, aggiungetevi le cipolle e le corazze degli astici e fate stufare per 5 minuti. Mescolateci il vino bianco e l'acqua e portate ad ebollizione. Fate ridurre il liquido a 2 tazze circa. Filtrate e mettete da parte. Sbollentate i dadi di carote in acqua salata fino a cuocerli al dente. Sbollentate 4 cucchiai di erba cipollina, scolate e riducete in purea con l'olio di vinacciolo. In una padella fate sciogliere 2 cucchiai di burro a fuoco medio, aggiungete le carote, 3 cucchiai di erba cipollina e lo zenzero. Fate cuocere per 1 minuto, mescolatevi quindi la polpa di astici, il riso per sushi e i germogli di piselli. In un tegame piccolo riscaldate il brodo di pollo, mescolatelo al fondo di cottura con 1 cucchiaio di burro e la purea di erba cipollina e correggete con sale e pepe. Mettete il risotto su un piatto, versatevi alcune gocce del fondo di cottura all'erba cipollina e decorate con il tartufo bianco.

L8

Design: Andrea Caputo, InArcDesign | Chef: Alex Stanclu

222 West Ontario Street | Chicago, IL 60610
Phone: +1 312 266 0616
www.l8chicago.com
Opening hours: Tue–Thu 5 pm to midnight, Fri–Sat 5 pm to 7 am, Sun-Mon closed
Average price: $ 16
Cuisine: Contemporary American with Italian influence
Special features: Sophisticated late-night restaurant

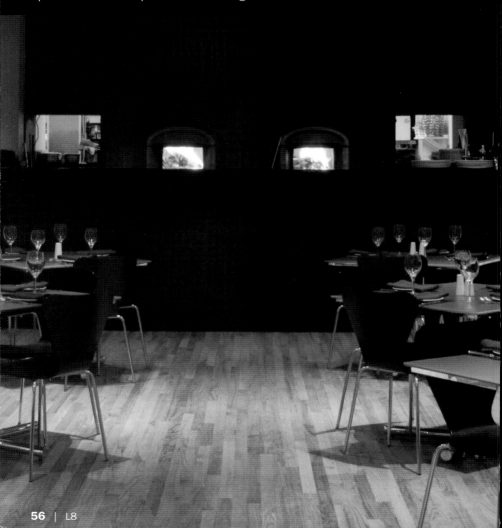

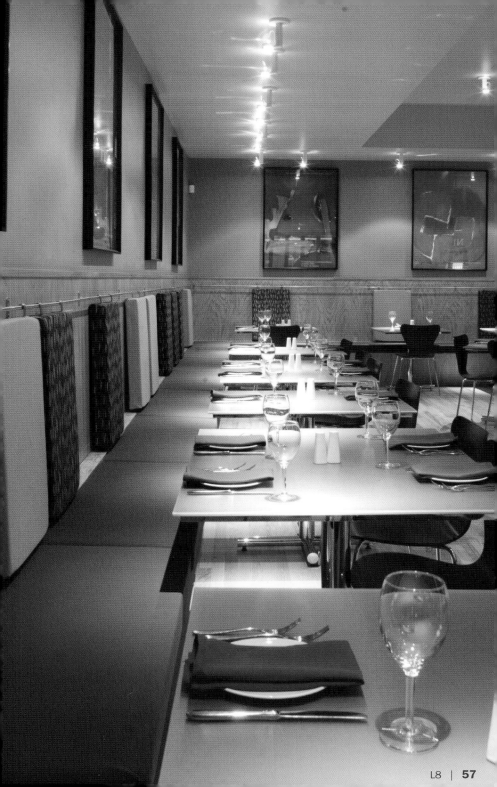

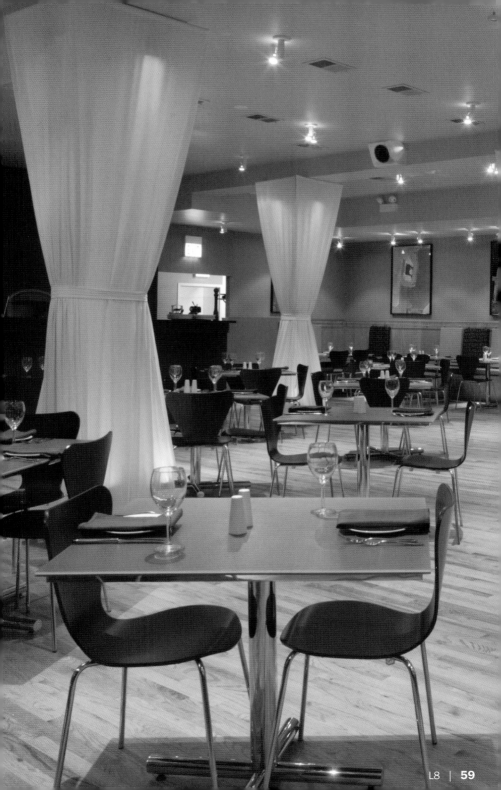

Monte Carlo Chicken

Hühnchen Monte Carlo

Poulet Monte Carlo

Pollito Montecarlo

Pollastro Monte Carlo

4 chicken breasts, skinned
Black pepper
8 sage leaves
8 slices Parma ham (thinly cut)
Flour
3 tbsp butter
6 tbsp white wine
6 tbsp chicken stock
8 slices Fontina cheese

Cut the chicken breasts in half. Season with pepper and cover with the sage and ham. Then toss in the flour and fry in hot butter for 1 minute on each side (ham side first). Add the wine and chicken stock, put the cheese on each chicken breast and bake in the oven at 340 °F, until the cheese melts. Serve with sautéed spinach.

4 Hühnerbrüste ohne Haut
Schwarzer Pfeffer
8 Salbeiblätter
8 Scheiben Parmaschinken (dünn geschnitten)
Mehl
3 EL Butter
6 EL Weißwein
6 EL Geflügelbrühe
8 Scheiben Fontinakäse

Hühnerbrüste halbieren. Mit Pfeffer würzen und mit Salbei und Schinken belegen. Anschließend in Mehl wenden und in heißer Butter auf jeder Seite 1 Minute braten (Schinkenseite zuerst). Den Wein und die Geflügelbrühe dazugeben, den Käse auf jedes Bruststück legen und bei 170 °C im Ofen backen, bis der Käse geschmolzen ist. Mit sautiertem Spinat servieren.

4 blancs de poulet sans peau
Poivre noir
8 feuilles de sauge
8 tranches fines de jambon de Parme
Farine
3 c. à soupe de beurre
6 c. à soupe de vin blanc
6 c. à soupe de bouillon de volaille
8 tranches de fromage de Fontina

Couper les blancs de poulet en deux. Assaisonner avec du poivre et mettre sur chacun une feuille de sauge et une tranche de jambon. Les passer ensuite dans la farine et les faire revenir 1 minute de chaque côté (le côté jambon en premier) dans du beurre chaud. Verser ensuite le vin et le bouillon de volaille, poser une tranche de fromage sur chaque morceau de blanc et mettre au four à 170 °C jusqu'à ce que le fromage soit fondu. Servir avec des épinards passés à la poêle.

4 pechugas de pollo sin piel
Pimienta negra
8 hojas de salvia
8 rodajas de jamón de Parma (cortadas finas)
Harina
3 cucharadas de mantequilla
6 cucharadas de vino blanco
6 cucharadas de caldo de ave
8 rodajas de queso de Fontina

Cortar las pechugas de pollo por la mitad. Sazonar con pimienta y cubrir con salvia y con jamón. A continuación, pasarlas por harina y freír en mantequilla por cada lado durante 1 minuto (primero la parte del jamón). Añadir el vino y el caldo de ave, poner el queso sobre cada pedazo de pechuga y asar al horno a 170 °C hasta que el queso se haya derretido. Servir con espinacas salteadas.

4 petti di pollo senza pelle
Pepe nero
8 foglie di salvia
8 fette di prosciutto di Parma (tagliate sottili)
Farina
3 cucchiai di burro
6 cucchiai di vino bianco
6 cucchiai di brodo di pollo
8 fette di Fontina

Dividete i petti di pollo a metà. Pepateli e ricopriteli con salvia e prosciutto. Passateli quindi nella farina e friggeteli nel burro bollente per 1 minuto per lato (iniziando con il lato ricoperto con il prosciutto). Aggiungete il vino e il brodo di pollo, mettete una fetta di formaggio su ogni pezzo di petto e fate cuocere in forno a 170 °C finché il formaggio si sarà sciolto. Servite con spinaci saltati.

Le Colonial

Design: Greg Jordan | Chef: Quoc Luong
Owners: Rick Wahlstedt, Jean Goutal

937 North Rush Street | Chicago, IL 60611
Phone: +1 312 255 0088
www.lecolonialchicago.com
Opening hours: Mon–Sun noon to 2:30 pm, Mon–Fri 5 pm to 11 pm,
Sat 5 pm to midnight, Sun 5 pm to 10 pm
Average price: Appetizers $ 6 – $ 9.50, entrees $ 14 – $ 24
Cuisine: French-Vietnamese
Special features: Quiet downstairs dining room, upstairs lounge, all season terrace

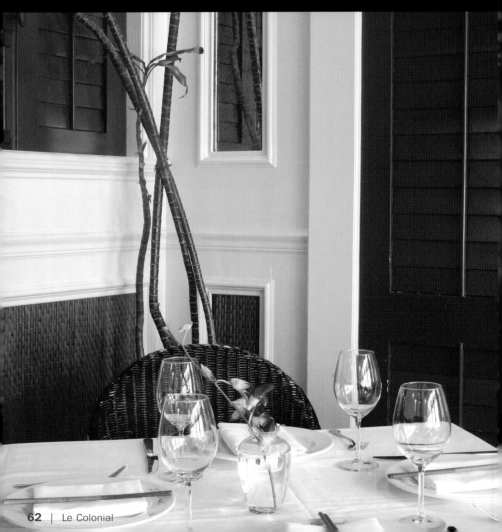

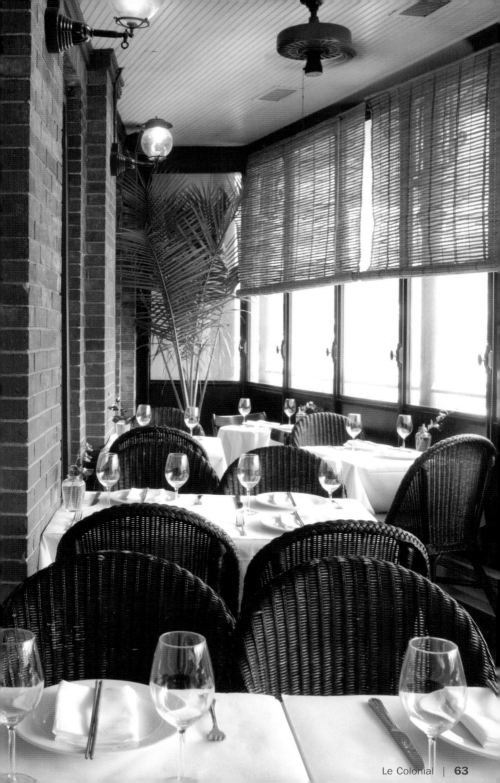

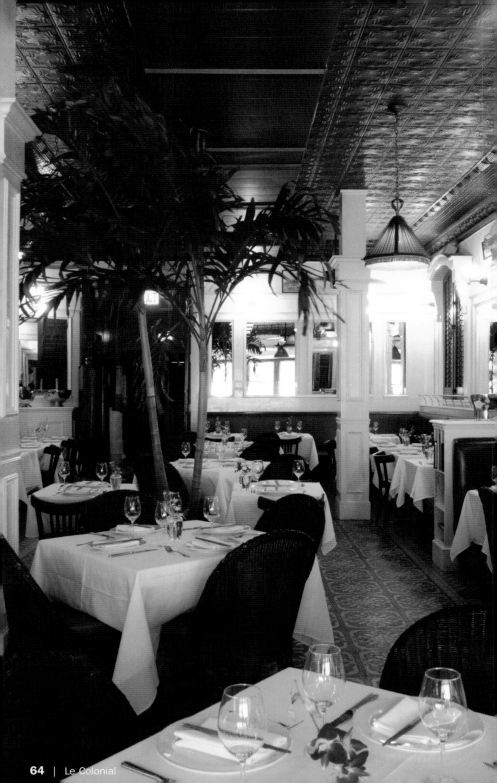

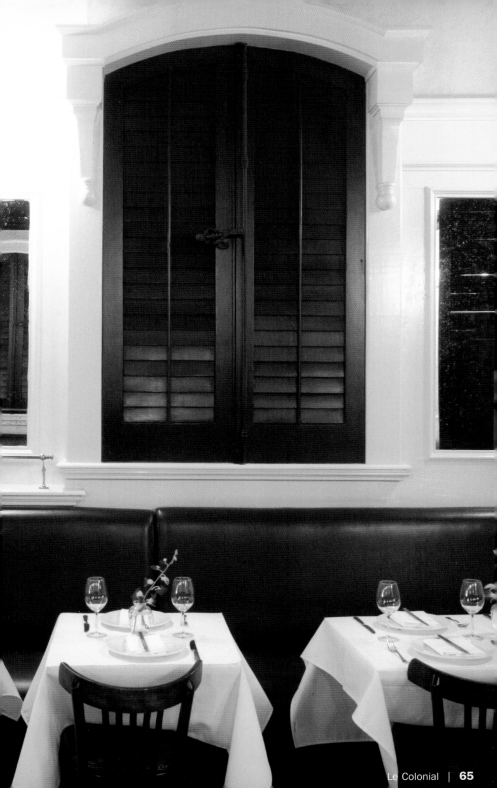

Goi Cuon

4 pieces dried rice paper (medium-sized)
12 medium shrimps, cooked and dressed
4 young lettuce leaves
4 oz cooked glass noodles
2 oz bean sprouts
12 mint leaves
4 tsp Chinese chives

Soak the rice paper in very hot water, drain on kitchen towel to absorb surplus water. Roll a portion of shrimps, lettuce, noodles, bean sprouts, mint leaves and chives in each piece of the rice paper. Cut into bite-size pieces (about 2 portions from each rice paper sheet). Serve with peanut sauce.

Peanut Sauce:
1 tbsp vegetable oil
1 tsp chopped garlic
1 tbsp chopped onions
90 ml Hoisin sauce
2 tbsp peanut butter
1 tsp sugar
90 ml water
1 tbsp coconut milk
1 tbsp peanuts, chopped
1 tbsp fresh chili, chopped

Heat the oil in a small saucepan and fry the garlic and onions until they are cooked, but not brown. Add the other ingredients and allow to simmer for 5 minutes. Garnish the sauce with chopped peanuts and chili.

4 Stück getrocknetes Reispapier (mittelgroß)
12 mittlere Shrimps, gekocht und ausgelöst
4 zarte Salatblätter
120 g gekochte Glasnudeln
60 g Bohnenkeimlinge
12 Minzblätter
4 TL Chinesischer Schnittlauch

Das Reispapier in sehr heißem Wasser einweichen, auf Küchenpapier abtropfen lassen, um überschüssiges Wasser aufzusaugen. Jeweils eine Portion Shrimps, Salat, Nudeln, Bohnenkeimlinge, Minzblätter und Schnittlauch in ein Reispapier einrollen. In mundgerechte Stücke schneiden (2 Stück aus einem Stück Reispapier). Mit Erdnusssauce servieren.

Erdnusssauce:
1 EL Pflanzenöl
1 TL Knoblauch, gehackt
1 EL Zwiebel, gehackt
90 ml Hoisinsauce
2 EL Erdnussbutter
1 TL Zucker
90 ml Wasser
1 EL Kokosmilch
1 EL Erdnüsse, gehackt
1 EL frische Chili, gehackt

In einem kleinen Topf das Öl erhitzen, Knoblauch und Zwiebel darin anschwitzen bis sie gar, aber nicht braun sind. Restliche Zutaten hinzufügen und für 5 Minuten köcheln lassen. Die Sauce mit gehackten Erdnüssen und Chili garnieren.

4 galettes de riz séchées (de taille moyenne)
12 crevettes de taille moyenne cuites et décor-
tiquées
4 feuilles de salade tendres
120 g de vermicelles chinois
60 g de germes de haricot
12 feuilles de menthe
4 c. à café de ciboulette chinoise

Mettre les galettes de riz à ramollir dans de l'eau
très chaude, les faire égoutter sur un papier
absorbant. Déposer sur chaque galette une
portion de crevettes, de salade, de vermicelles,
de germes de haricot, de feuilles de menthe et
de ciboulette puis les rouler. Couper ensuite les
rouleaux en morceaux de la taille d'une bouchée
(2 morceaux par galette). Servir avec une sauce
au cacahuètes.

Sauce aux cacahuètes :
1 c. à soupe d'huile végétale
1 c. à café d'ail hachée
1 c. à soupe d'oignon haché
90 ml de sauce Hoisin
2 c. à soupe de beurre de cacahuètes
1 c. à café de sucre
90 ml d'eau
1 c. à soupe de lait de noix de coco
1 c. à soupe de cacahuètes hachées
1 c. à soupe de piment frais haché

Faire chauffer l'huile dans une petite casserole,
y faire revenir l'ail et l'oignon jusqu'à ce qu'ils
soient cuits mais pas brunis. Ajouter les autres
ingrédients et laisser mijoter 5 minutes. Ajouter
à la fin sur le dessus les cacahuètes hachées et
le piment.

4 pedazos de papel de arroz seco (medianos)
12 gambas medianas, cocidas y sin cáscara
4 hojas de lechugas tiernas
120 g de fideos chinos cocidos
60 g de brotes de judías
12 hojas de menta
4 cucharaditas de cebollino chino

Poner a remojar el papel de arroz en agua muy
caliente, escurrir en papel de cocina para que
se absorba el agua sobrante. Enrollar una ración
de gambas, lechuga, fideos, brotes de judías,
hojas de menta y cebollino en una hoja de arroz
respectivamente. Cortar a pedazos pequeños (2
pedazos de cada papel de arroz). Servir con salsa
de cacahuetes.

Salsa de cacahuetes:
1 cucharada de aceite vegetal
1 cucharadita de ajo, picado
1 cucharada de cebolla, picada
90 ml de salsa Hoisin
2 cucharadas de mantequilla de cacahuetes
1 cucharadita de azúcar
90 ml de agua
1 cucharada de leche de coco
1 cucharada de cacahuetes, picados
1 cucharada de chile fresco, picado

Calentar el aceite en una olla pequeña, freir en
ella el ajo y la cebolla hasta que estén hechos
pero no dorados. Añadir el resto de los ingre-
dientes y hervir a fuego lento durante 5 minutos.
Adornar la salsa con cacahuetes y chile picados.

4 pezzi di carta di riso essiccata (di media gran-
dezza)
12 gamberetti medi lessati e sgusciati
4 foglie di insalata tenera
120 g di spaghetti di riso lessati
60 g di germogli di fagioli
12 foglie di menta
4 cucchiaini di erba cipollina cinese

Ammorbidite la carta di riso in acqua molto
calda e fatela sgocciolare su carta assorbente da
cucina per fare assorbire l'acqua in eccesso. In
ogni pezzo di carta di riso avvolgete una porzione
di gamberetti, insalata, spaghetti, germogli di
fagioli, foglie di menta ed erba cipollina. Tagliate
a bocconcini (2 per ogni pezzo di carta di riso).
Servite con salsa di arachidi.

Salsa di arachidi:
1 cucchiaio di olio vegetale
1 cucchiaino di aglio tritato
1 cucchiaino di cipolla tritata
90 ml di salsa hoisin
2 cucchiai di burro di arachidi
1 cucchiaino di zucchero
90 ml di acqua
1 cucchiaio di latte di cocco
1 cucchiaio di arachidi tritate
1 cucchiaio di peperoncino fresco tritato

In un tegame piccolo riscaldate l'olio e fatevi
dorare l'aglio e la cipolla finché saranno cotti ma
non troppo scuri. Aggiungete gli altri ingredienti e
fate cuocere a fuoco lento per 5 minuti. Guarnite
la salsa con arachidi e peperoncino tritati.

Mirai

Design: Miae Lim | Chef: Jun Ichikawa

2020 West Division Street | Chicago, IL 60622
Phone: +1 773 862 8500
Opening hours: Sun–Wed 5 pm to 10:30 pm, Thu–Sat 5 pm to 11:30 pm
Average price: $ 35
Cuisine: Japanese
Special features: Upscale city's trendy sushi set

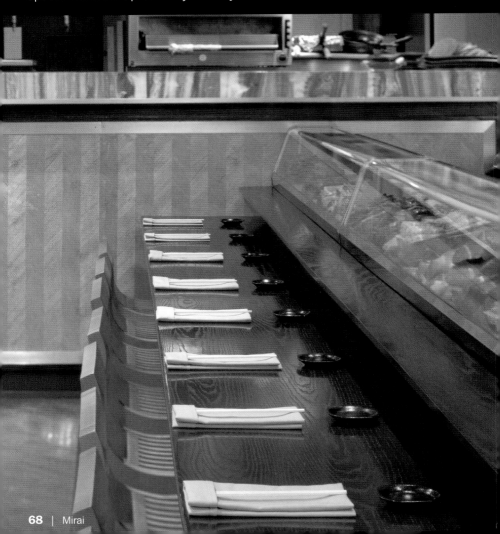

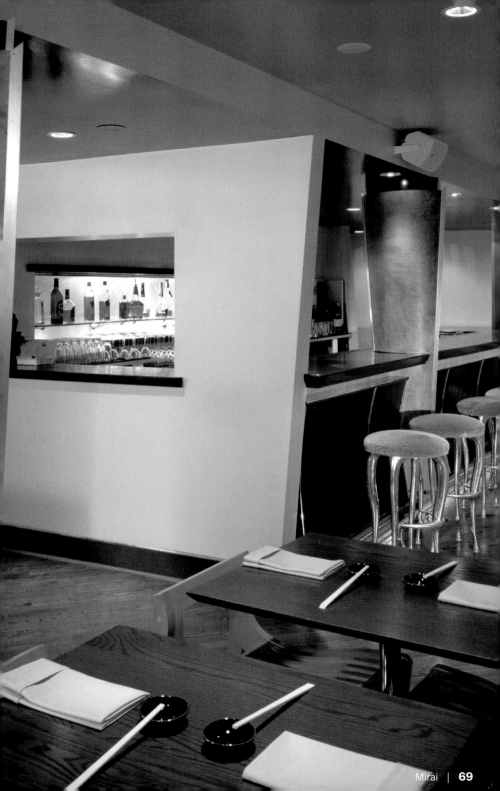

MOD

Design: Suhail Design Studio | Chef: Andrew Zimmerman
Owners: Terry Alexander, Randi Lee, Kristin Skrainy

1520 North Damen Avenue | Chicago, IL 60622
Phone: +1 773 252 1500
www.modrestaurant.net
Opening hours: Mon–Thu 5 pm to 10:30 pm, Fri–Sat 5 pm to 11:30 pm,
Sun 10 am to 2:30 pm and 5 pm to 10 pm
Average price: $ 28
Cuisine: Modern American

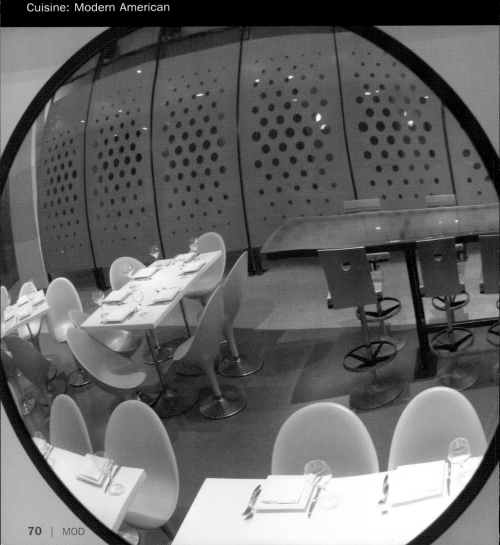

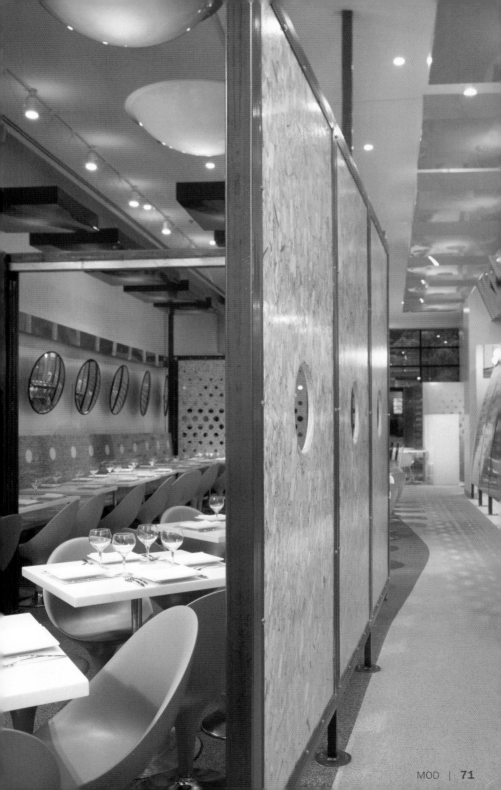

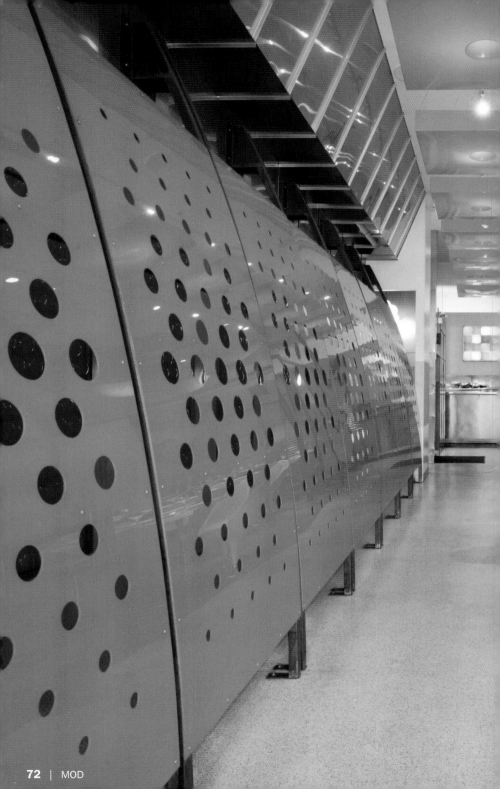

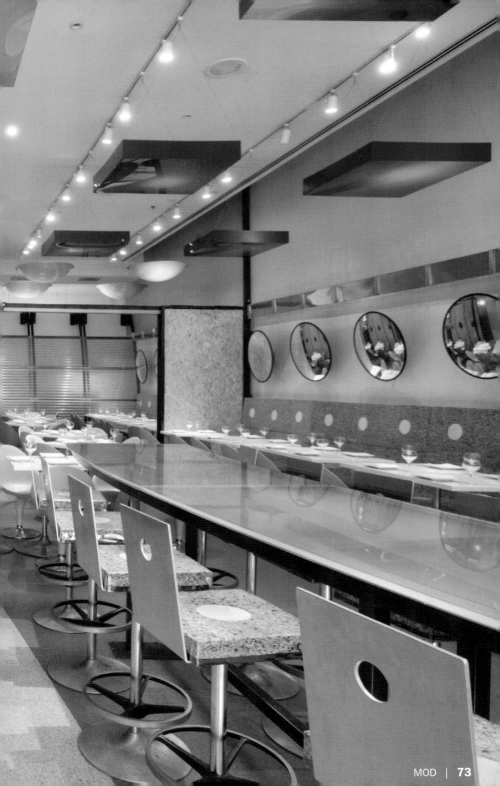

Sautéed Pumpkin Gnocchi
with Duck and Swiss Chard

Sautierte Kürbis-Gnocchi mit Ente
und Mangold

Gnocchi de potiron au canard et aux bettes

Gnocchi salteados a la calabaza con pato
y acelgas

Gnocchi di zucca saltati con anatra
e bietole

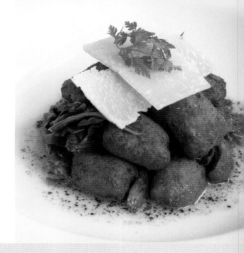

Gnocchi:
1 small pumpkin, quartered and seeded
1 lb potatoes
1 large egg, lightly whisked
3 oz grated Parmesan
1 tsp fresh thyme, chopped
1 tsp fresh sage, chopped
Salt and pepper
A pinch of nutmeg
Flour

Duck and Swiss Chard:
4 pickled duck drumsticks (from the delicatessen)
11 tbsp butter
3 lb Swiss chard, with leaf panicles removed and cut into strips
5–8 fresh sage leaves
Salt and pepper
Juice of half a lemon

Cook the pumpkin and potatoes until soft, purée and allow to cool. Mix with the egg, cheese, thyme, sage and season with salt, pepper and nutmeg. If necessary, add extra flour. Make gnocchi out of the dough and cook in boiling, salted water, then pour off the liquid. Put the drumsticks in a pre-heated pan and fry until brown. Remove the duck from the pan and drain off the fat. Leave the drumsticks to cool on a board and lift the meat off the bone. Fry the gnocchi until golden brown in 5 tbsp of heated butter. Meanwhile, sauté the Swiss chard in 6 tbsp of butter, season with salt and pepper. Mix the gnocchi, duck and Swiss chard carefully in a large pot. Heat the butter in a saucepan, add the sage and lemon juice and sprinkle over the gnocchi-duck dish.

Gnocchi:
1 kleiner Kürbis, geviertelt und entkernt
500 g Kartoffeln
1 großes Ei, leicht verquirlt
90 g Parmesan, gerieben
1 TL frischer Thymian, gehackt
1 TL frischer Salbei, gehackt
Salz, Pfeffer
Prise Muskat
Mehl

Ente und Mangold:
4 eingelegte Entenschlegel (Feinkosthandel)
11 EL Butter
1,5 kg Mangold, von Blattrispen befreit, in Streifen
5–8 frische Salbeiblätter
Salz, Pfeffer
Saft einer halben Zitrone

Den Kürbis und die Kartoffeln weich kochen, pürieren und abkühlen lassen. Mit Ei, Käse, Thymian und Salbei mischen und mit Salz, Pfeffer und Muskat würzen. Falls nötig etwas Mehl dazugeben. Aus dem Teig Gnocchi formen und in kochendem Salzwasser garen, dann abgießen. Entenschlegel in eine vorgeheizte Pfanne legen und braun anbraten. Schlegel aus der Pfanne nehmen und Fett abgießen. Entenschlegel auf einem Brett abkühlen lassen und das Fleisch vom Knochen lösen. Die Gnocchi in 5 EL heißer Butter goldbraun braten. In der Zwischenzeit den Mangold in 6 EL Butter sautieren, mit Salz und Pfeffer würzen. In einem großen Topf die Gnocchi, Entenfleisch und Mangold vorsichtig mischen. Butter in einer Pfanne erhitzen, Salbei und Zitronensaft dazugeben und über das Gnocchi-Entengericht träufeln.

Gnocchi :
1 petit potiron dont on a enlevé les pépins, coupé en quatre
500 g de pommes de terre
1 gros œuf légèrement battu
90 g de parmesan râpé
1 c. à café de thym frais haché
1 c. à café de sauge fraîche hachée
Sel, poivre
Une pincée de muscade
Farine

Canard et bettes :
4 cuisses de canard marinées (en épicerie fine)
11 c. à soupe de beurre
1,5 kg de bettes épluchées et coupées en bandes
5–8 feuilles de sauge fraîche
Sel, poivre
Le jus d'un demi-citron

Cuire le potiron et les pommes de terre, les écraser en purée et laisser refroidir. Ajouter l'œuf, le fromage, le thym et la sauge puis assaisonner avec le sel, le poivre et la muscade. Si nécessaire, ajouter un peu de farine. Former avec cette pâte les gnocchi et les mettre à cuire dans de l'eau bouillante salée, puis égoutter. Mettre les cuisses de canard dans une poêle préalablement chauffée et les faire revenir jusqu'à ce qu'elles soient dorées. Les retirer et jeter la graisse fondue. Les faire refroidir sur une planche puis détacher la viande des os. Faire dorer les gnocchi dans 5 c. à soupe de beurre chaud. Entre temps faire revenir les bettes dans 6 c. à soupe de beurre, saler et poivrer. Mélanger ensuite délicatement dans une grande sauteuse les gnocchi, le canard et les bettes. Dans une poêle chauffer le beurre, la sauge et le jus de citron et verser cette sauce sur les gnocchi.

Gnocchi:
1 calabaza pequeña, a cuartos y sin pepitas
500 g de patatas
1 huevo grande, ligeramente batido
90 g de queso parmesano, rallado
1 cucharadita de tomillo fresco, picado
1 cucharadita de salvia fresca, picada
Sal, pimienta
Una pizca de nuez moscada
Harina

Pato y acelgas:
4 muslos de pato macerados (tienda de exquisiteces)
11 cucharadas de mantequilla
1,5 kg de acelgas sin panojas, a tiras
5–8 hojas de salvia fresca
Sal, pimienta
El zumo de medio limón

Cocinar la calabaza y las patatas hasta que estén tiernas, hacer un puré y dejar enfriar. Mezclar con el huevo, el queso, el tomillo y la salvia y sazonar con sal, pimienta y nuez moscada. En caso de que sea necesario, añadir algo de harina. Formar gnocchi con la pasta y cocer en agua hirviendo con sal, después escurrir. Poner los muslos de pato en una sartén precalentada y freírlos hasta que estén dorados. Sacar los muslos de la sartén y verter la grasa. Dejar enfriar los muslos de pato sobre una tabla y separar la carne de los huesos. Freír los gnocchi en 5 cucharadas de mantequilla caliente hasta que estén dorados. Entretanto, saltear las acelgas en 6 cucharadas de mantequilla y sazonar con sal y pimienta. Mezclar con cuidado los gnocchi, la carne de pato y las acelgas en una olla grande, calentar la mantequilla en una sartén, añadir la salvia y el zumo de limón y verter sobre el plato de gnocchi con pato.

Gnocchi:
1 zucca piccola divisa in quattro e privata dei semi
500 g di patate
1 uovo grosso leggermente sbattuto
90 g di parmigiano grattugiato
1 cucchiaino di timo fresco tritato
1 cucchiaino di salvia fresca tritata
Sale, pepe
Pizzico di noce moscata
Farina

Anatra e bietole:
4 cosce di anatra marinate (negozio di specialità gastronomiche)
11 cucchiai di burro
1,5 kg di bietole, ripulite da coste e a listarelle
5–8 foglie di salvia fresca
Sale, pepe
Succo di mezzo limone

Lessate bene la zucca e le patate, riducetele in purea e lasciate raffreddare. Mescolate con uovo, formaggio, timo e salvia e condite con sale, pepe e noce moscata. Se necessario, aggiungete un po' di farina. Ricavate degli gnocchi dall'impasto, fateli cuocere in acqua salata bollente e scolateli. In una padella preriscaldata mettete le cosce di anatra e fatele rosolare finché saranno ben dorate. Togliete le cosce dalla padella e scolate il grasso. Lasciate raffreddare le cosce di anatra su un tagliere e disossate la carne. Friggete gli gnocchi in 5 cucchiai di burro bollente finché diventeranno di un colore ben dorato. Nel frattempo saltate le bietole in 6 cucchiai di burro, salate e pepate. In una pentola grande mescolate con cautela gli gnocchi, la carne di anatra e le bietole. In una padella riscaldate il burro, aggiungete la salvia e il succo di limone e versatene alcune gocce sul piatto di gnocchi e anatra.

N9NE / Ghost Bar

Design: Scott DeGraff, Michael Morton| Chef: Jesse Fultinieer

440 West Randolph Street | Chicago, IL 60606
Phone: +1 312 575 9900
www.N9NE.com
Opening hours: Mon–Wed 5:30 pm to 10:00 pm, Thu 5:30 pm to 11:00 pm,
Fri– Sat 5:00 pm to midnight, closed Sun
Ghost Bar: Fri 8:30 pm to 2:00 am, Sat 8:30 pm to 3:00 am
Average price: $ 70
Cuisine: Contemporary American Steakhouse

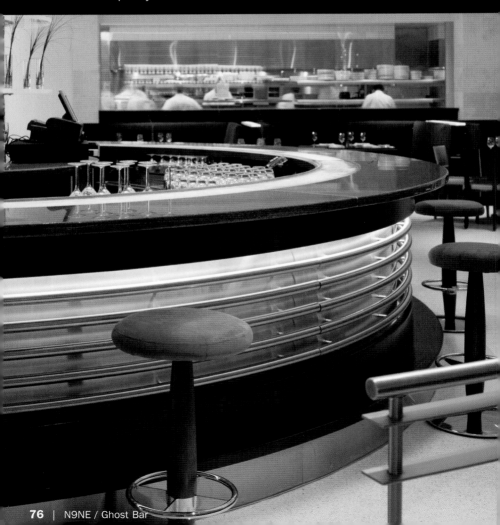

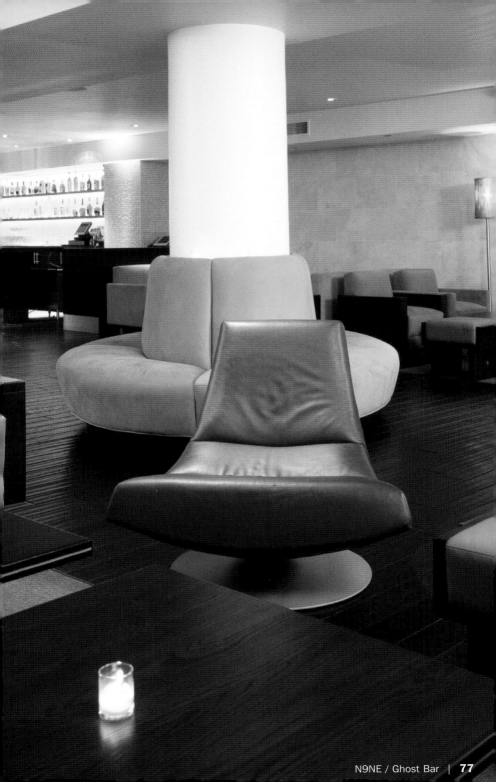

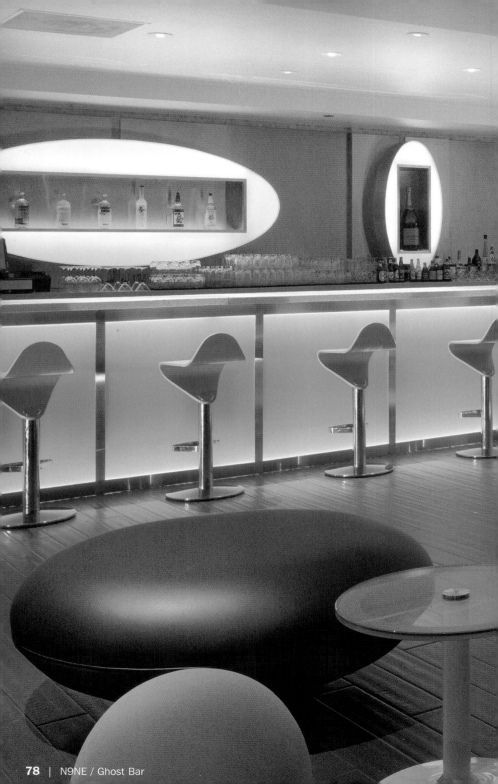

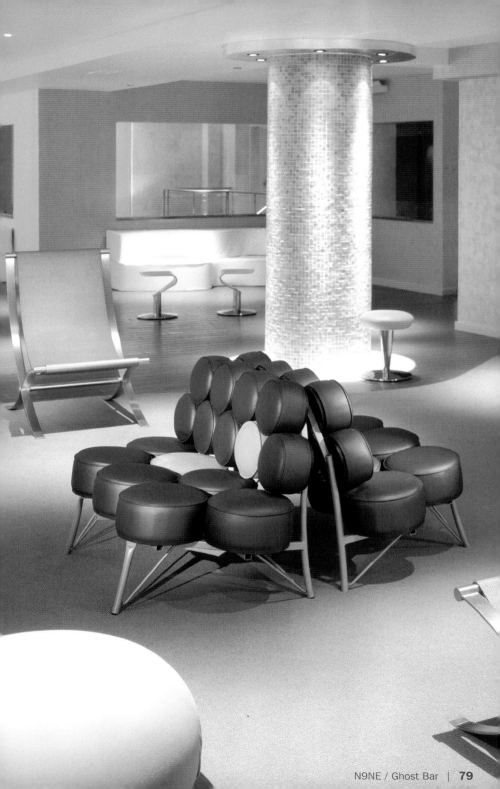

Average price: $ 30
Cuisine: Contemporary American with Mediterranean flavor
Special features: Window tables revealing urban skyline

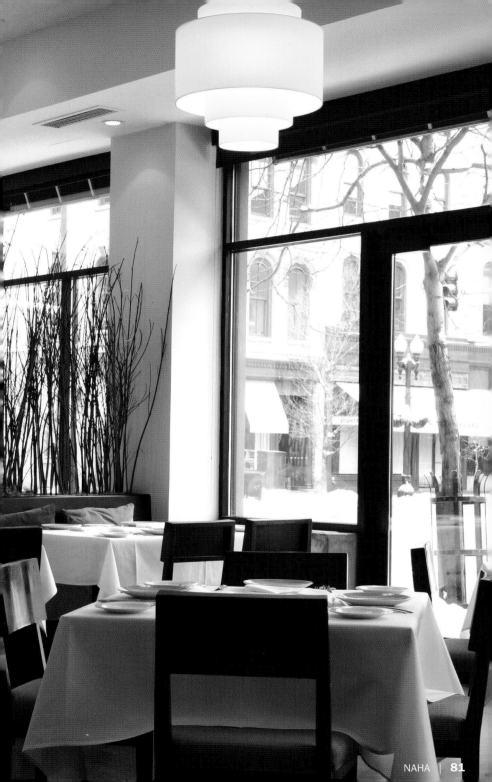

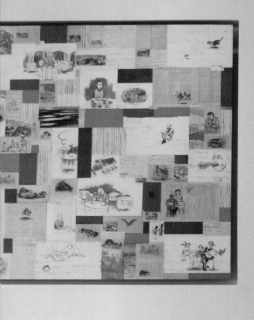

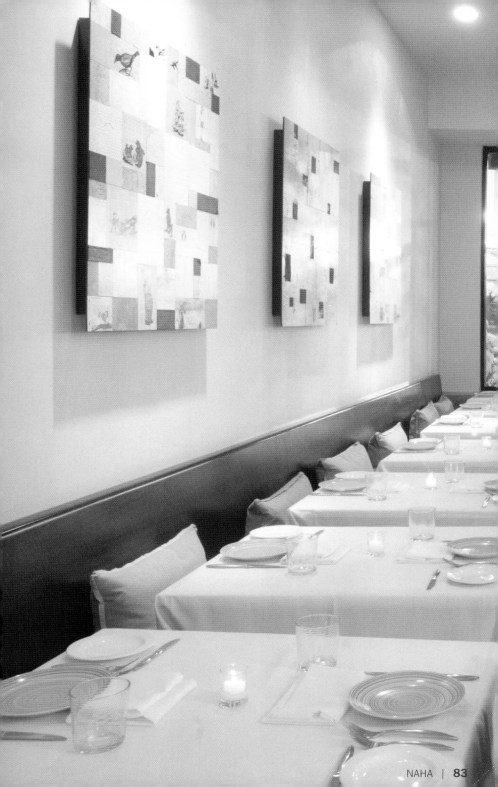

Red Snapper

with Butternut Squash and Celery Purée

Red Snapper mit Butternuss-Squash und Selleriepüree

Red snapper à la courge musquée et à la purée de céleri

Chillo con squash de mantequilla de nuez y puré de apio

Snapper rosso con zucca butternut e purea di sedano

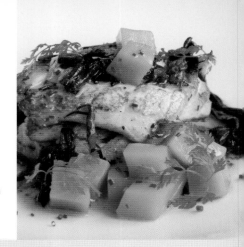

1 celery root, peeled and diced
180 ml milk
6 tbsp butter
2 medium butternut squash (breed of pumpkin and zucchini), peeled and diced
240 ml chicken stock
4 pieces red snapper fillet, about 6 ½ oz each
3 tbsp olive oil
Salt and pepper
4 tbsp chives, chopped

Place the celery in a pan, cover with milk and bring to the boil. Cook until soft. Remove the celery from the milk and purée in a mixer until smooth. Season with 3 tbsp of butter, salt and pepper. Bring the chicken stock to the boil, add the diced butternut squash, 2 tbsp of butter and spices and place in a pre-heated oven at 350 °F. Simmer for about 15 minutes, until they are soft. Sprinkle salt and pepper over the red snapper and fry in hot oil on each side for 2 minutes. To finish cooking, set the fillets in the oven for 5 minutes. Remove the dices of squash from the liquid and keep warm. Use some of the left-over liquid to make a light juice with the chives and 1 tbsp of butter. Place the celery purée in the middle of the dish, arrange the red snapper fillet on top and scatter the diced squash around the fish. Sprinkle with chive juice.

1 Sellerieknolle, geschält und gewürfelt
180 ml Milch
6 EL Butter
2 mittlere Butternuss-Squash (Züchtung aus Kürbis und Zucchini), geschält und gewürfelt
240 ml Geflügelbrühe
4 Stück Red-Snapper-Filet, je 180 g
3 EL Olivenöl
Salz, Pfeffer
4 EL Schnittlauch, gehackt

Sellerie in einen Topf legen, mit Milch bedecken und aufkochen lassen. Weich garen. Sellerie aus der Milch nehmen und in einem Mixer glatt pürieren. Mit 3 EL Butter, Salz und Pfeffer abschmecken. Geflügelbrühe aufkochen, den gewürfelten Butternuss-Squash, 2 EL Butter und Gewürze zugeben und in einen auf 180 °C vorgeheizten Ofen geben. Für ca. 15 Minuten schmoren, bis sie weich sind. Red Snapper mit Salz und Pfeffer würzen und in heißem Öl auf jeder Seite 2 Minuten braten. Zum Fertiggaren die Filets für 5 Minuten in den Ofen schieben. Squashwürfel aus der Flüssigkeit nehmen und warm stellen. Etwas Garflüssigkeit benutzen, um eine leichte Jus mit dem Schnittlauch und 1 EL Butter zuzubereiten. Das Selleriepüree in die Mitte des Tellers geben, das Red-Snapper-Filet darauf platzieren und die Squashwürfel darum verteilen. Mit Schnittlauchjus beträufeln.

1 céleri-rave épluché et coupé en dés
180 ml de lait
6 c. à soupe de beurre
2 courges musquées (variété de courge entre le potiron et la courgette), pelées et coupées en dés
240 ml de bouillon de volaille
4 filets de red snapper (vivineau), de 180 g chacun
3 c. à soupe d'huile d'olive
Sel, poivre
4 c. à soupe de ciboulette hachée

Mettre le céleri dans une casserole, le couvrir de lait et le faire cuire. Le retirer ensuite du lait et le passer au mixeur pour en faire une purée. Ajouter 3 c. à soupe de beurre, le sel et le poivre. Faire chauffer le bouillon de volaille, y ajouter les dés de courge, 2 c. à soupe de beurre et les épices et mettre au four préchauffé à 180 °C. Laisser mijoter pendant environ 15 minutes jusqu'à ce que les légumes soient cuits. Saler et poivrer les filets de red snapper et les faire revenir dans l'huile de chaque côté pendant 2 minutes. Les mettre au four pendant 5 minutes pour terminer la cuisson. Egoutter les dés de courge et les garder au chaud. Mélanger un peu du liquide de cuisson à la ciboulette et à 1 c. à soupe de beurre pour faire un jus. Mettre la purée de céleri au milieu de l'assiette, déposer le filet de poisson au dessus et répartir les dés de courge autour. Arroser de quelques gouttes de jus de ciboulette.

1 apio, pelado y en cuadraditos
180 ml de leche
6 cucharadas de mantequilla
2 squash medianos de mantequilla de nuez (cultivo de calabaza y calabacín), pelados y en cuadraditos
240 ml de caldo de ave
4 filetes de chillo de 180 g cada uno
3 cucharadas de aceite de oliva
Sal, pimienta
4 cucharadas de cebollino, picado

Poner el apio en una olla, cubrir con leche y dar un hervor. Cocer hasta que esté tierno. Sacar el apio de la leche y hacer un puré suave. Sazonar con 3 cucharadas de mantequilla, sal y pimienta. Dar un hervor al caldo de ave, añadir el squash de mantequilla de nuez a cuadraditos, 2 cucharadas de mantequilla y los condimentos y poner al horno precalentado a 180 °C. Asar durante aprox. 15 minutos hasta que esté tierno. Sazonar el chillo con sal y pimienta y freír en aceite caliente 2 minutos por cada lado. Poner los filetes al horno durante 5 minutos para acabarlos de asar. Sacar los cuadraditos de squash del líquido y mantener caliente. Utilizar algo del líquido de cocer para preparar un jugo ligero con el cebollino y 1 cucharada de mantequilla. Poner el puré de apio en el centro del plato, colocar encima el filete de chillo y esparcir alrededor los cuadraditos de squash. Rociar con el jugo del cebollino.

1 sedano rapa pelato e tagliato a dadini
180 ml di latte
6 cucchiai di burro
2 zucche butternut (incrocio tra zucca e zucchina), medie pelate e tagliate a dadini
240 ml di brodo di pollo
4 pezzi di filetto di snapper rosso da 180 g ciascuno
3 cucchiai di olio d'oliva
Sale, pepe
4 cucchiai di erba cipollina tritata

Mettete il sedano in un tegame, copritelo con il latte e portate ad ebollizione. Fate cuocere il sedano finché sarà ben lessato. Togliete il sedano dal latte e frullatelo in un frullatore fino ad ottenere un composto omogeneo. Insaporite con 3 cucchiai di burro e correggete con sale e pepe. Portate ad ebollizione il brodo di pollo, aggiungete la zucca butternut tagliata a dadini, 2 cucchiai di burro e spezie, e passate in forno preriscaldato a 180 °C. Fate stufare il tutto per circa 15 minuti finché non sarà tenero. Salate e pepate lo snapper rosso e friggetelo in olio bollente per 2 minuti per lato. Finite di cuocere i filetti passandoli in forno per 5 minuti. Togliete i dadini di zucca dal liquido e metteteli in caldo. Usate un po' di liquido di cottura per preparare un sugo leggero con l'erba cipollina e 1 cucchiaio di burro. Mettete la purea di sedano al centro del piatto, disponetevi sopra il filetto di snapper rosso e distribuite intorno i dadini di zucca. Versatevi alcune gocce del sugo all'erba cipollina.

NoMi at the Park Hyatt

Design: Tony Chi & Associates | Chef: Sandro Gamba

800 North Michigan Avenue | Chicago, IL 60611
Phone: +1 312 239 4030
www.nomirestaurant.com
Opening hours: Mon–Fri 6:30 am to 10:30 am, 11:30 am to 2:30 pm, 5:30 pm to 10:30 pm, Sat–Sun 7 am to 2:30 pm, 5:30 pm to 10:30 pm
Average price: $ 45
Cuisine: French-American
Special features: Tables 30 to 37 feature the best Magnificent Mile views

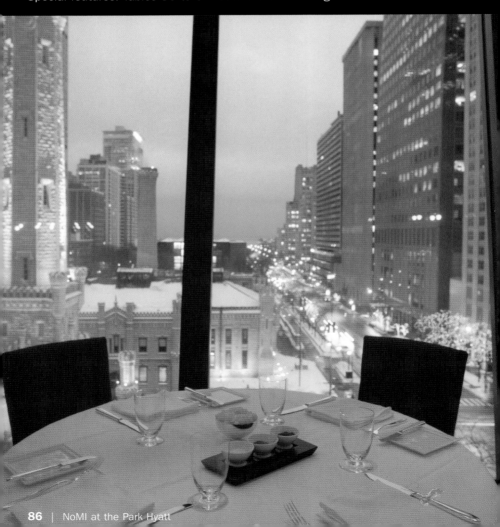

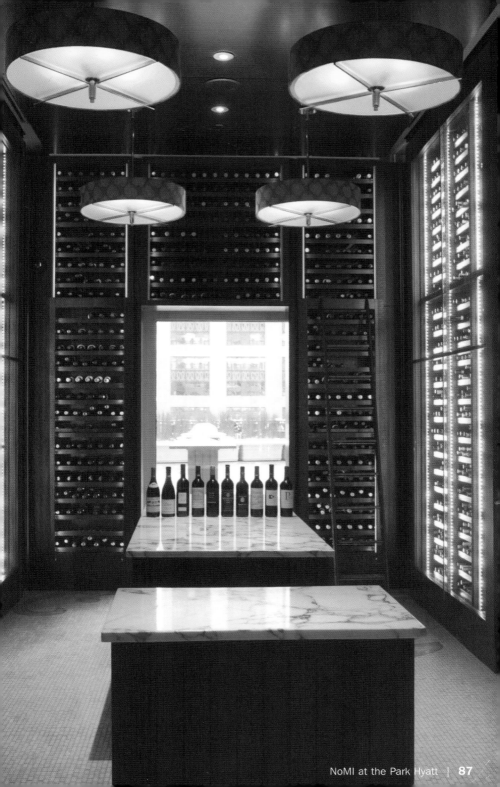

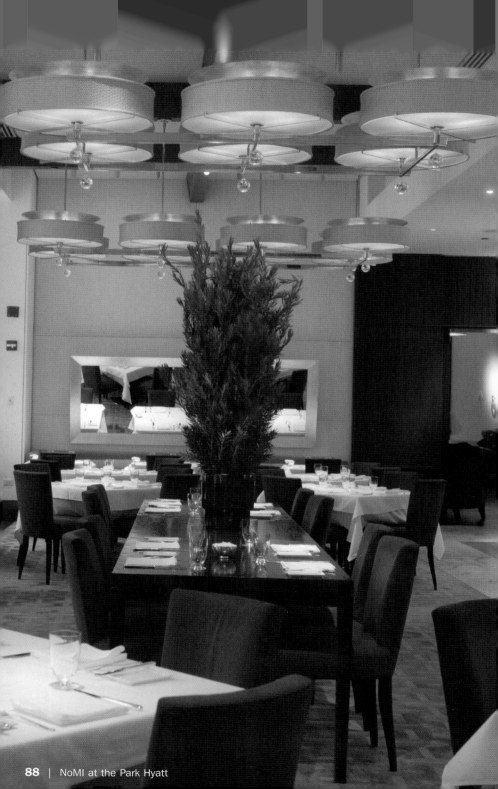

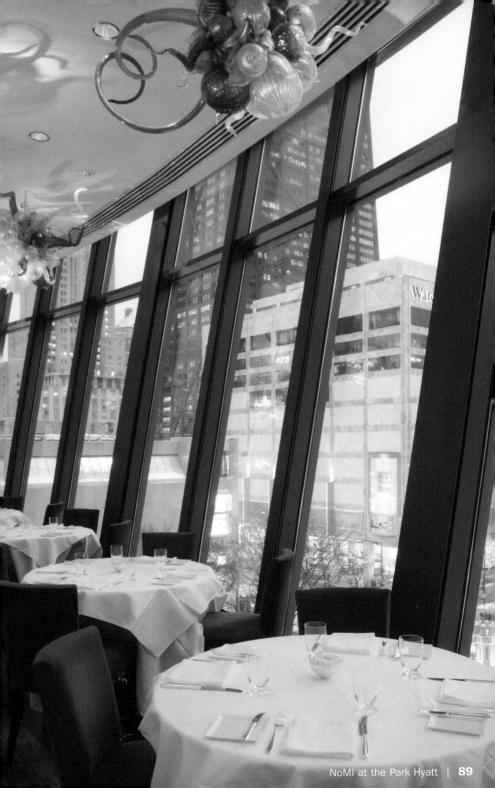

NoMI at the Park Hyatt | **89**

one sixtyblue

Design: Adam T. Tihany | Chef: Martial Noguier
Owner: Michael Jordan

160 North Loomis Street | Chicago, IL 60607
Phone: +1 312 850 0303
www.onesixtyblue.com
Opening hours: Mon–Thu 5:30 pm to 10 pm, Fri–Sat 5:30 pm to 11 pm
Average price: $ 50
Cuisine: Contemporary French
Special features: Elegant and sophisticated environment framing Chicago's skyline

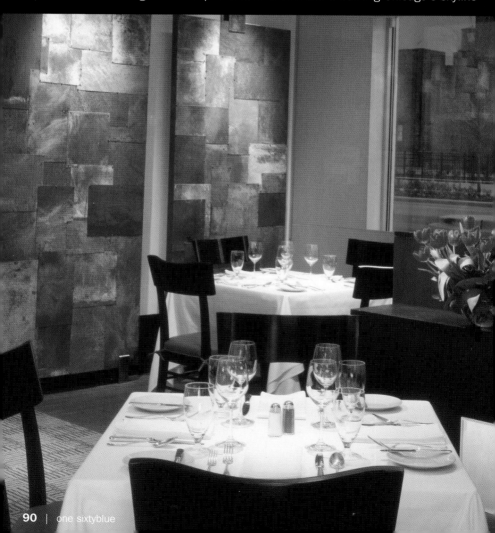

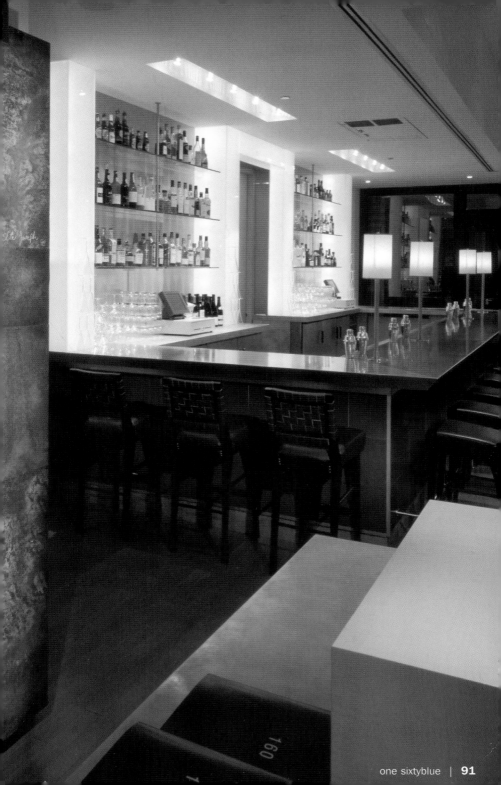

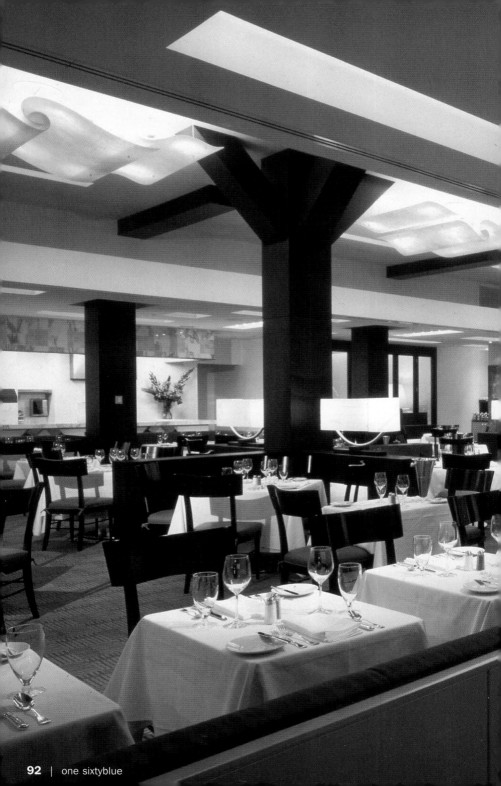

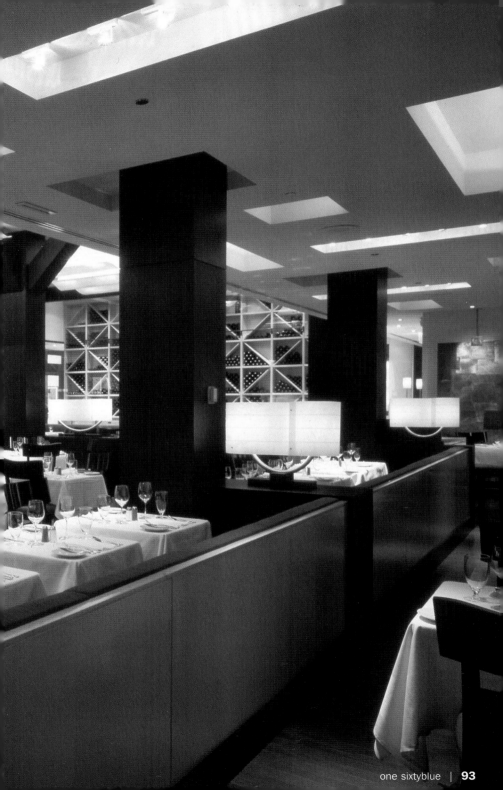

Opera

Design: Jerry Kleiner | Chef: Paul Wildermuth

1301 South Wabash Street | Chicago, IL 60605
Phone: +1 312 461 0161
www.opera-chicago.com
Opening hours: Sun–Wed 5 pm to 10 pm, Thu 5 pm to 11 pm,
Fri–Sat 5 pm to midnight
Average price: $ 25
Cuisine: Chinese with modern presentations
Special features: Mini private "vaults" provide romantic tables for two or four; the
rooms actually used to be movie reel storage vaults in the former warehouse

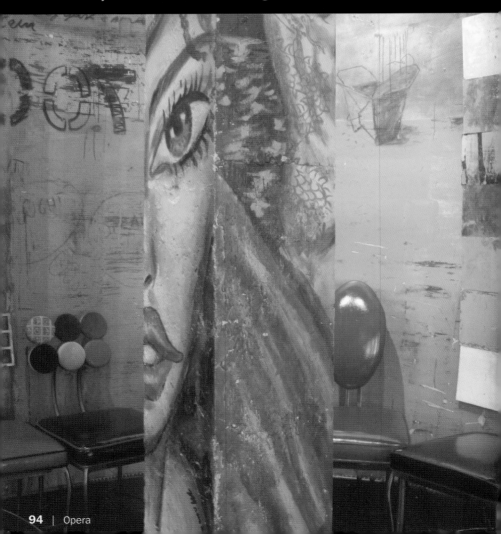

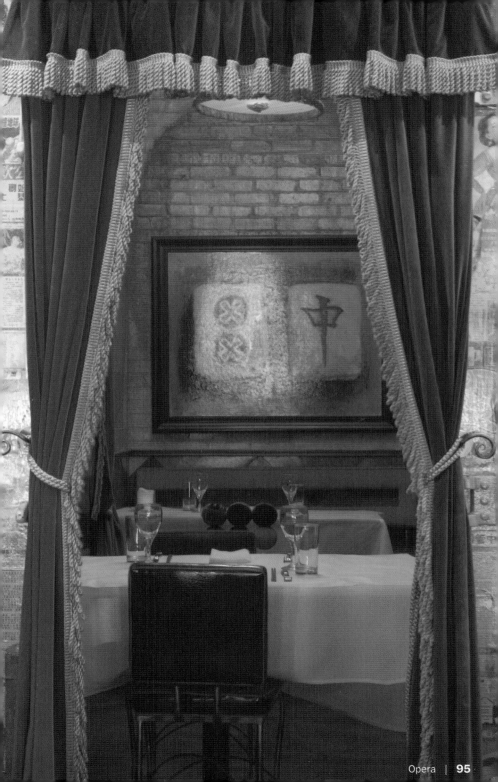

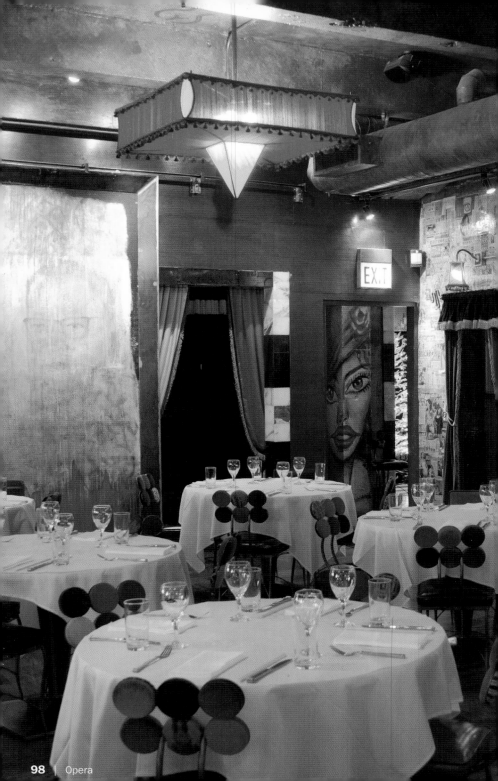

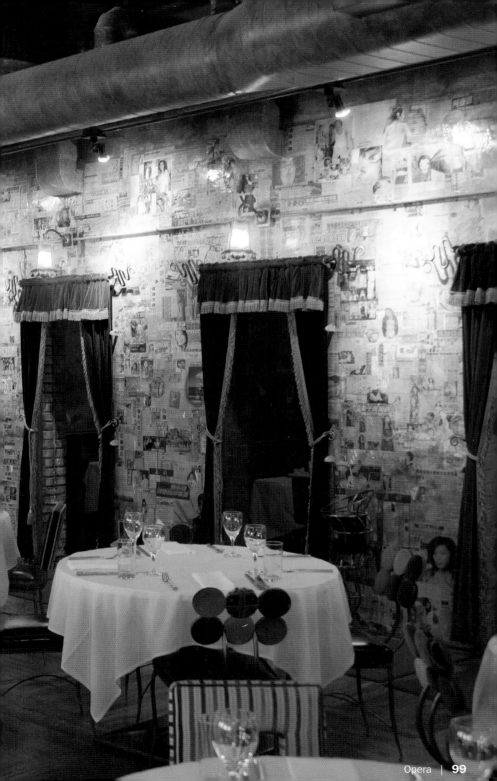

Kung Pao Beef

Kung Pao Rind

Bœuf Kung Pao

Carne de res Kung Pao

Manzo Kung Pao

5 tbsp corn oil
4 steaks, 6 1/2 oz each (New York Strip)
Salt and pepper
Cornstarch
5 Thai chilis
60 ml chili-garlic sauce
30 ml Hoisin sauce
60 ml sweet chili sauce
2 oz sugar
1 oz coriander, chopped
2 oz peanuts, roasted
1 oz chopped spring onions
1 tsp sesame oil
2 baby Bok Choi (Chinese leaf variety), steamed

Heat the oil in a pan or wok, season the steaks with salt and pepper, toss in the cornstarch and place in the very hot fat. Lightly fry on each side. Remove the steaks from the pan, add the chilis, sauces and remaining ingredients and mix well. Add the steaks and pour over the marinade. Leave on the heat until the steaks are medium rare. Serve on a plate, sprinkled with sesame oil and steamed baby Bok Choi.

5 EL Maisöl
4 Steaks, à 180 g (New York Strip)
Salz, Pfeffer
Speisestärke
5 Thai-Chilis
60 ml Chili-Knoblauchsauce
30 ml Hoisinsauce
60 ml süße Chilisauce
60 g Zucker
30 g Koriander, gehackt
60 g Erdnüsse, geröstet
30 g Frühlingszwiebeln, gehackt
1 TL Sesamöl
2 Baby Bok Choi (Chinakohl-Sorte), gedünstet

Öl in einer Pfanne oder Wok erhitzen, Steaks mit Salz und Pfeffer würzen, in der Speisestärke wenden und in das sehr heiße Fett geben. Auf beiden Seiten kurz anbraten. Steaks aus der Pfanne nehmen, Chilis, Saucen und restliche Zutaten hineingeben und gut mischen. Steaks hinzufügen und mit der Marinade überziehen. Auf dem Feuer lassen, bis die Steaks medium-durch sind. Auf einen Teller geben, mit Sesamöl beträufeln und mit gedünstetem Baby Bok Choi servieren.

5 c. à soupe d'huile de maïs
4 steaks de 180 g chacun (New York Strip)
Sel, poivre
Maïzena
5 piments thaï
60 ml de sauce à l'ail et au piment
30 ml de sauce Hoisin
60 ml de sauce sucrée au piment
60 g de sucre
30 g de coriandre hachée
60 g de cacahuètes grillées
30 g d'oignons de printemps hachés
1 c. à café d'huile de sésame
2 baby bok choi (sorte de petit chou chinois) cuits
à la vapeur

Mettre l'huile à chauffer dans une poêle ou un wok, saler et poivrer les steaks, les passer dans la maïzena et les mettre dans l'huile très chaude. Les faire revenir rapidement des deux côtés. Les retirer et mettre dans la poêle les piments, les sauces et le reste des ingrédients, bien mélanger. Remettre les steaks et les couvrir avec la marinade. Les laisser sur le feu jusqu'à ce qu'ils soient cuits à point. Les poser sur une assiette et parsemer quelques gouttes d'huile de sésame sur le dessus puis servir avec les baby bok choi.

5 cucharadas de aceite de maíz
4 bistec de 180 g cada uno (New York Strip)
Sal, pimienta
Fécula para espesar
5 chiles Thai
60 ml de salsa de ajo y chile
30 ml de salsa Hoisin
60 ml de salsa de chile dulce
60 g de azúcar
30 g de cilantro, picado
60 g de cacahuetes, tostados
30 g de cebolletas, picadas
1 cucharadita de aceite de sésamo
2 Baby Bok Choi (tipo col rizada), rehogadas

Calentar el aceite en una sartén o en un wok, sazonar los bistec con sal y pimienta, pasar por la fécula para espesar y poner en la grasa muy caliente. Freír brevemente por ambos lados. Sacar los bistec de la sartén, añadir los chiles, las salsas y el resto de los ingredientes y mezclar bien. Añadir los bistec y cubrir con la marinada. Dejar al fuego hasta que los bistec estén medio hechos. Poner en un plato, rociar con aceite de sésamo y servir con el Baby Bok Choi rehogado.

5 cucchiai di olio di mais
4 bistecche da 180 g (New York Strip)
Sale, pepe
Amido di mais
5 peperoncini tailandesi
60 ml di salsa di peperoncino e aglio
30 ml di salsa hoisin
60 ml di salsa di peperoncino dolce
60 g di zucchero
30 g di coriandolo tritato
60 g di arachidi tostate
30 g di cipollotto tritato
1 cucchiaino di olio di sesamo
2 baby bok choi (tipo di cavolo cinese) stufati

In una padella o in un wok riscaldate l'olio, salate e pepate le bistecche, passatele nell'amido di mais e mettetele nell'olio bollente. Fatele rosolare per qualche istante su ogni lato. Togliete le bistecche dalla padella, versate nella padella i peperoncini, le salse e gli altri ingredienti, e mescolate bene. Aggiungete le bistecche e ricoprite con la marinata. Lasciate sulla fiamma finché le bistecche saranno quasi cotte. Mettetele su un piatto, versatevi alcune gocce di olio di sesamo e servite con baby bok choi stufati.

Sound Bar

Design: Rocco Laudizio

226 West Ontario Street | Chicago, IL 60610
Phone: +1 312 787 4480
www.sound-bar.com
Opening hours: Thu–Fri 9 pm to 4 am, Sat 9 pm to 5 am, Sun–Wed closed
Special features: Two dance floors and nine separate bar areas, international DJs
spin nightly

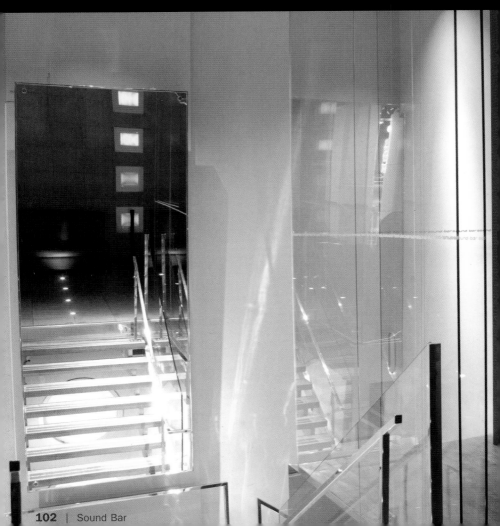

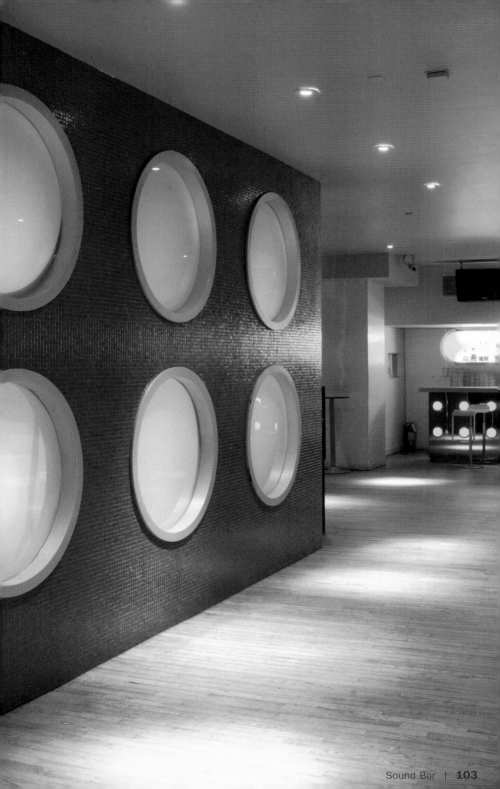

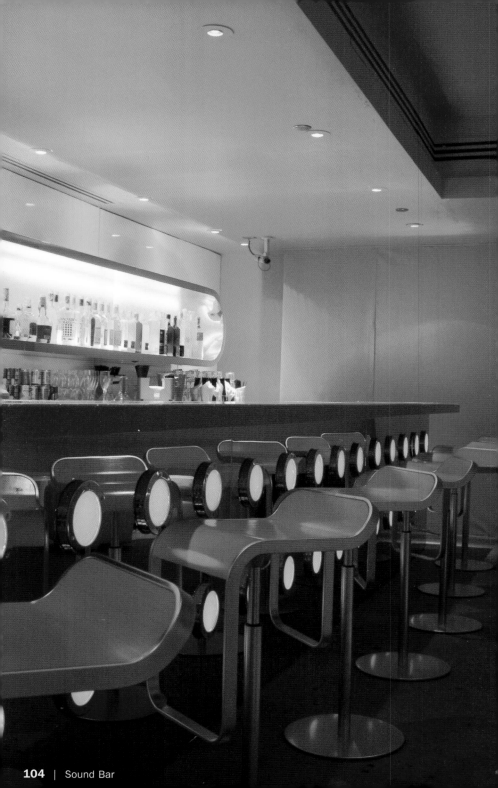

Lady in Red
Cocktail

3 cl Stolichnaya Razberi
3 cl Stolichnaya Peach
1 cl Amaretto
1 cl pineapple juice
1 cl cranberry juice

Put all the ingredients in a cocktail shaker,
mix well and serve in a Martini glass.

3 cl Stolichnaya Razberi
3 cl Stolichnaya Peach
1 cl Amaretto
1 cl Ananassaft
1 cl Preiselbeersaft

Alle Zutaten in einen Cocktailshaker geben,
gut mischen und in einem Martiniglas servieren.

3 cl de Stolichnaya Razberi
3 cl de Stolichnaya Peach
1 cl d'Amaretto
1 cl de jus d'ananas
1 cl de jus d'airelles

Verser tous les ingrédients dans un shaker,
bien mélanger et servir dans un verre à Martini.

3 cl de Stolichnaya Razberi
3 cl de Stolichnaya Peach
1 cl de Amaretto
1 cl de zumo de piña
1 cl de zumo de arándanos rojos

Poner todos los ingredientes en una coctelera,
mezclar bien y servir en un vaso de Martini.

3 cl di Stolichnaya Razberi
3 cl di Stolichnaya Peach
1 cl di Amaretto
1 cl di succo d'ananas
1 cl di succo di mirtilli rossi

Mettete tutti gli ingredienti in uno shaker,
shakerate bene e servite in un bicchiere da
Martini.

Sugar

Design: Suhail Design Studio | Chef: Christine McCabe

108 West Kinzie Street | Chicago, IL 60610
Phone: +1 312 822 9999
Opening hours: Sun–Fri 5 pm to 2 am, Sat 5 pm to 3 am
Average price: $ 15
Cuisine: Dessert bar
Special features: Chicago's only dessert bar, offering high-end desserts with inspired names

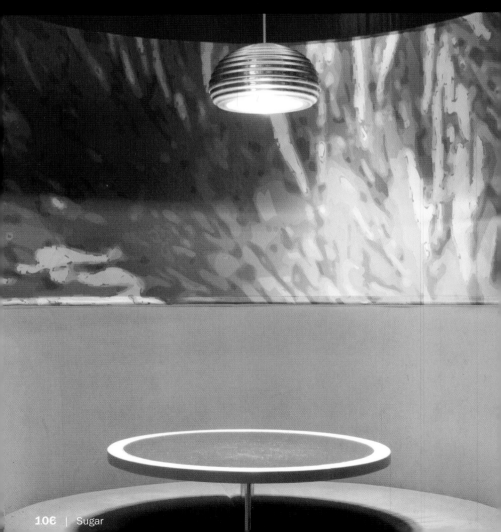

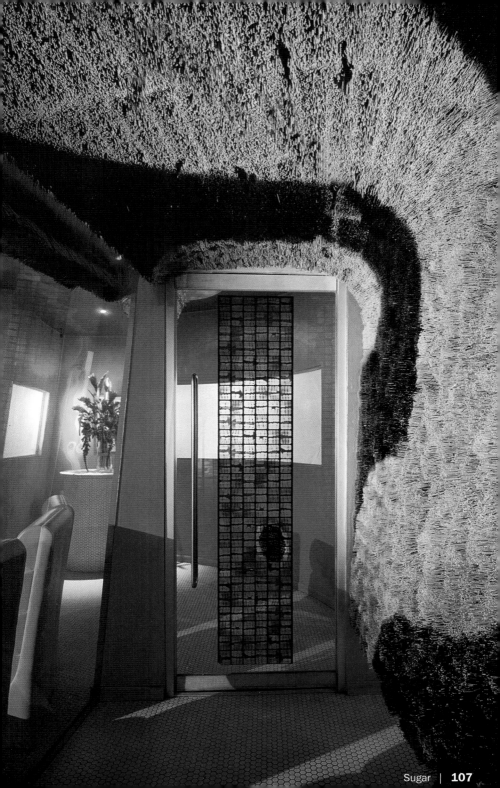

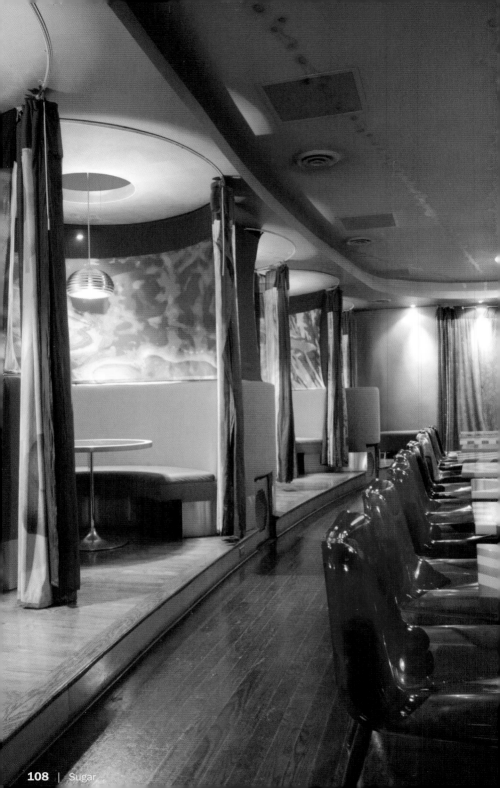

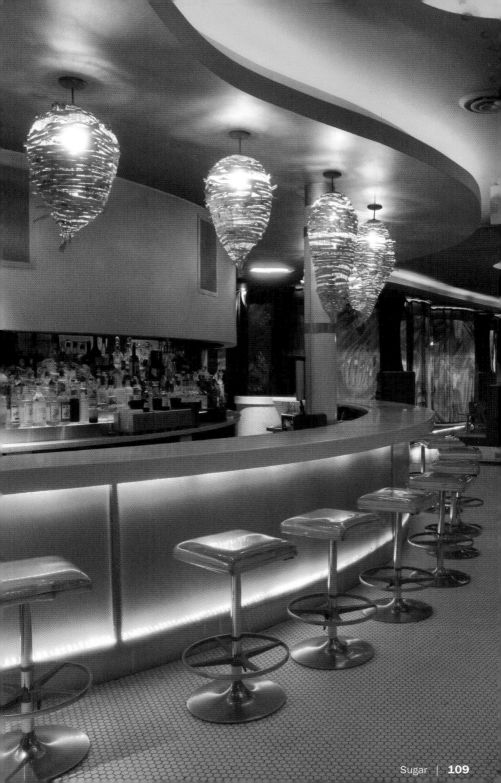

Tarzan of the Crêpes

Tarzan der Crêpes

Tarzan de crêpes

Tarzan de las crepes

Tarzan delle crêpe

14 oz half-bitter chocolate, chopped
12 tbsp butter
10 egg yolks
3 oz sugar
2 egg whites
200 ml cream
4 bananas, in slices
3 oz brown sugar
3 tbsp rum
Vanilla ice-cream

Crêpe Mixture:
3 1/2 oz flour
2 eggs
300 ml milk
2 tbsp butter, melted

Melt 9 tbsp of butter and chocolate in a steam bath. Beat up the egg yolks and 2 oz of sugar in a bowl to give a gluey texture. Set aside. Beat the egg whites and 1 oz of sugar until the mixture is semi-firm. Store in the refrigerator. Whip the cream until smooth. Stir the egg yolks into the chocolate mixture, then fold in the egg white and cream. Pour into a square bowl, lined with clear foil and store in the refrigerator for about 2 hours. Mix the ingredients for the crêpes in a bowl, store in the refrigerator for 1 hour and then make small crêpes out of the batter. Put the bananas, sugar and 3 tbsp of butter in a saucepan and simmer at medium heat until the butter has melted. Add the rum and continue to cook until the sugar has dissolved. Cut the chocolate mousse into square pieces and serve with the warm bananas, crêpes and vanilla ice-cream.

400 g Halbbitterschokolade, gehackt
12 EL Butter
10 Eigelb
90 g Zucker
2 Eiweiß
200 ml Sahne
4 Bananen, in Scheiben
100 g brauner Zucker
3 EL Rum
Vanilleeis

Crêpe-Teig:
100 g Mehl
2 Eier
300 ml Milch
2 EL Butter, geschmolzen

9 EL Butter und Schokolade im Wasserbad schmelzen. In einer Schüssel die Eigelbe und 60 g Zucker sämig aufschlagen. Beiseite stellen. Eiweiß und 30 g Zucker halbfest aufschlagen. Kaltstellen. Sahne cremig schlagen. Eigelbe mit der Schokoladenmischung verrühren, dann den Eischnee und die Sahne unterheben. In eine eckige Schüssel gießen, die mit Frischhaltefolie ausgelegt ist und für ca. 2 Stunden kaltstellen. Crêpe-Teigzutaten in einer Schüssel vermischen, für eine Stunde kaltstellen und kleine Crêpes daraus backen. Bananen, Zucker und 3 EL Butter in einen kleinen Topf geben, bei mittlerer Hitze köcheln, bis die Butter geschmolzen ist, den Rum dazugeben und weiterkochen, bis sich der Zucker aufgelöst hat. Schokoladenmousse in rechteckige Stücke schneiden und mit den warmen Bananen, den Crêpes und Vanilleeiscreme servieren.

400 g de chocolat noir haché
12 c. à soupe de beurre
10 jaunes d'œuf
90 g de sucre
2 blancs d'œuf
200 ml de crème
4 bananes coupées en rondelles
100 g de sucre brun
3 c. à soupe de rhum
Glace à la vanille

Pâte à crêpes :
100 g de farine
2 œufs
300 ml de lait
2 c. à soupe de beurre fondu

Faire fondre au bain-marie 9 c. à soupe de beurre avec le chocolat. Mettre les jaunes d'œuf et 60 g de sucre dans une terrine et battre jusqu'à ce que le mélange soit mousseux. Réserver. Battre les blancs en neige pas trop ferme avec 30 g de sucre. Mettre au frais. Fouetter la crème en chantilly. Mélanger les jaunes d'œuf au chocolat, puis ajouter les blancs montés en neige et la crème fouettée. Verser dans une terrine rectangulaire tapissée de film alimentaire et mettre au froid pendant environ 2 heures. Mélanger les ingrédients de la pâte à crêpes dans une terrine, laisser reposer pendant une heure et ensuite en faire de petites crêpes. Mettre dans une petite casserole les bananes, le sucre et 3 c. à soupe de beurre, chauffer sur feu doux jusqu'à ce que le beurre soit fondu, ajouter alors le rhum et laisser cuire jusqu'à ce que le sucre soit fondu. Former des rectangles avec la mousse refroidie et servir avec les bananes chaudes, les crêpes et la glace à la vanille.

400 g de chocolate semiamargo, picado
12 cucharadas de mantequilla
10 yemas de huevo
90 g de azúcar
2 claras de huevo
200 ml de nata
4 plátanos, a rodajas
100 g de azúcar moreno
3 cucharadas de ron
Helado de vainilla

Masa de las crepes:
100 g de harina
2 huevos
300 ml de leche
2 cucharadas de mantequilla, fundida

Fundir 9 cucharadas de mantequilla y el chocolate al baño María. Batir en una fuente las yemas de huevo y 60 g de azúcar hasta espesar. Poner aparte. Batir las claras de huevo y 30 g de azúcar hasta que estén semisólidos. Poner a enfriar. Batir la nata hasta que esté cremosa. Mezclar las yemas de huevo con la mezcla del chocolate, entonces incorporar al huevo a punto de nieve y a la nata. Verter en una fuente cuadrada revestida de papel transparente y poner a enfriar durante aprox. 2 horas. Mezclar en una fuente los ingredientes para la masa de las crepes, poner a enfriar durante una hora y hacer de ellos crepes pequeñas. Poner en una olla pequeña los plátanos, el azúcar y 3 cucharadas de mantequilla, cocinar a fuego mediano hasta que la mantequilla esté fundida, añadir el ron y seguir cociendo hasta que el azúcar se haya disuelto. Cortar el mousse de chocolate a pedazos cuadrados y servir con los plátanos calientes, las crepes y el helado de vainilla.

400 g di cioccolato semifondente tritato
12 cucchiai di burro
10 tuorli d'uovo
90 g di zucchero
2 albumi
200 ml di panna
4 banane a rondelle
100 g di zucchero di canna
3 cucchiai di rum
Gelato alla vaniglia

Impasto per le crêpe:
100 g di farina
2 uova
300 ml di latte
2 cucchiai di burro fuso

Sciogliete 9 cucchiai di burro e il cioccolato a bagnomaria. In una ciotola montate i tuorli d'uovo e 60 g di zucchero fino ad ottenere un composto denso. Mettete da parte. Montate gli albumi e 30 g di zucchero fino ad ottenere un composto semisolido. Mettete a raffreddare. Montate la panna finché sarà cremosa. Mescolate i tuorli d'uovo con il miscuglio di cioccolato, quindi incorporate gli albumi montati a neve e la panna. Versate il composto in una ciotola con angoli rivestita di pellicola per alimenti e mettete a raffreddare per 2 ore circa. In una ciotola mescolate gli ingredienti per l'impasto delle crêpe, mettete a raffreddare per 1 ora e ricavateci quindi delle piccole crêpe. In un tegame piccolo mettete le banane, lo zucchero e 3 cucchiai di burro, fate cuocere a fuoco medio finché il burro si sarà sciolto, aggiungete il rum e continuate a cuocere finché lo zucchero si sarà sciolto. Tagliate la mousse di cioccolato in pezzi rettangolari e servite con le banane calde, le crêpe e la crema di gelato alla vaniglia.

SushiSamba rio

Design: David Rockwell & Rockwell Group
Chefs: Robert Ash, Shigeru Kitano

504 North Wells Street | Chicago, IL 60610
Phone: +1 312 595 2300
www.sushisamba.com
Opening hours: Sun–Tue 11:45 am to 11 pm, Wed–Thu 11:45 am to midnight,
Fri 11:45 am to 1 am, Sat 11:45 am to 2 am, Tue–Sat enclosed rooftop open after 5 pm
Average price: $ 35
Cuisine: Brazilian, Japanese, Peruvian
Special features: Latin DJ spins after 9 pm Thu–Sat

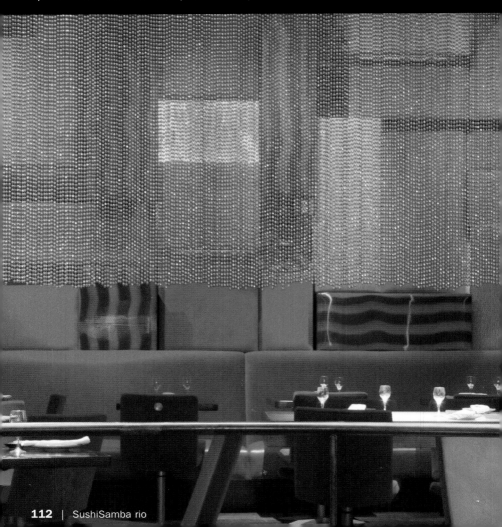

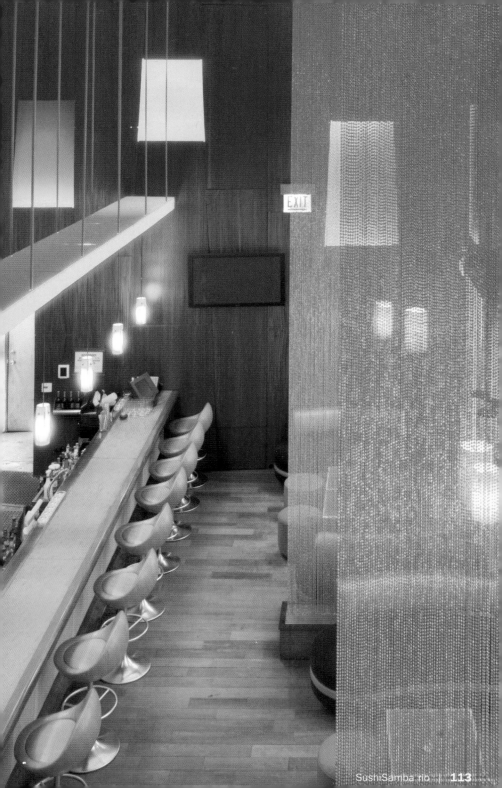

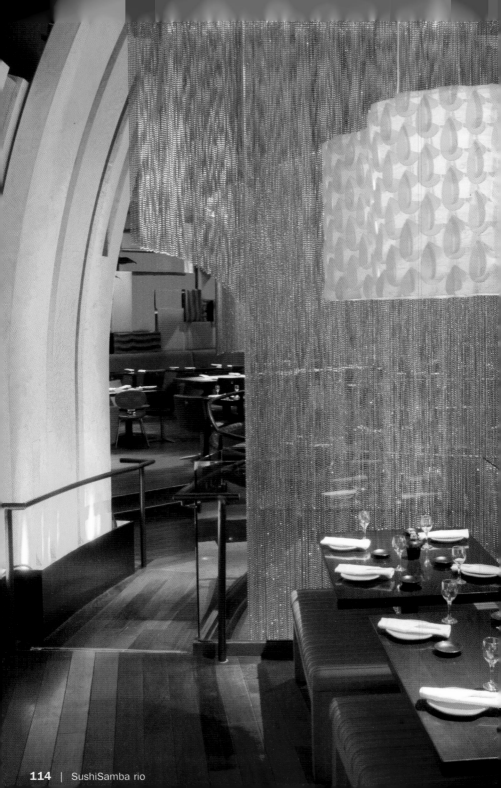

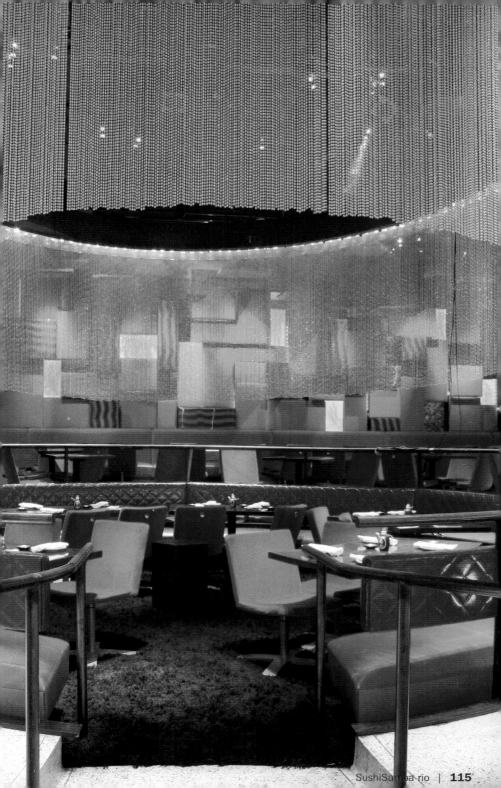

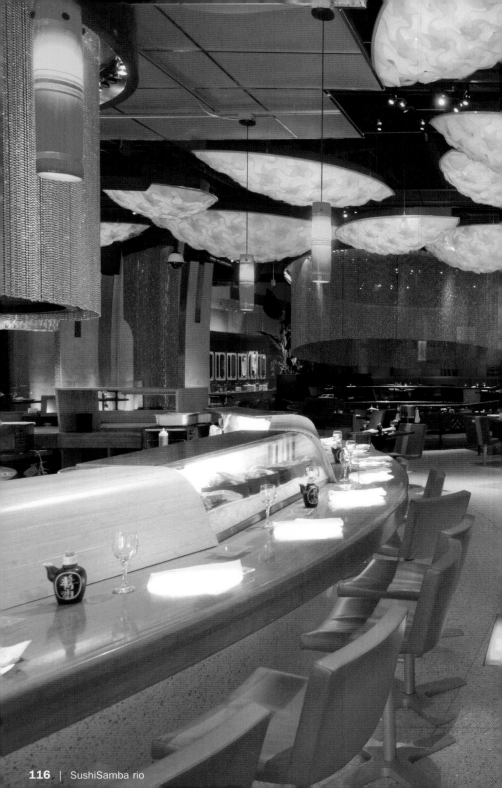

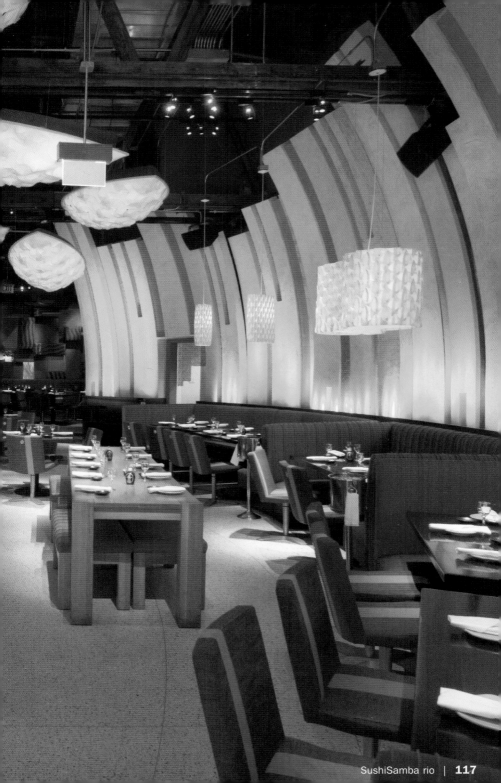

Mixed Sea Food Moqueca

Gemischtes Meeresfrüchte-Moqueca

Moqueca de fruits de mer

Moqueca de mariscos variados

Moqueca di frutti di mare mista

2 tbsp olive oil
12 mussels
12 clams
12 shrimps
1 small, white onion, diced
2 oz bacalhau (dried cod)
2 tomatoes, peeled and diced
2 oz okra, in slices
1 chopped garlic clove
240 ml fish stock
240 ml coconut milk
4 tsp coconut oil (Dendê)
2 tbsp coriander, chopped
4 fresh water cray fish-tails, cooked
4 oz squid rings, cooked
4 fresh water crabs, whole and cooked
2 tbsp lime juice
4 tbsp roasted cashew nuts

4 tbsp chopped spring onions
Salt and pepper

Heat the oil in a pan and add the mussels, clams, shrimps, onions, bacalhau, tomatoes, okra and garlic. Cook at a high temperature for approx. 1 minute, until the mussels begin to open. Cover with the fish stock and add the coconut milk, coconut oil and coriander and cook for 2 to 3 minutes. Add the cray fish-tails, squid rings and whole shrimps. Season with lime juice, salt and pepper. Place in a casserole and garnish with cashew nuts and spring onions.

2 EL Olivenöl
12 Miesmuscheln
12 Venusmuscheln
12 Shrimps
1 kleine weiße Zwiebel, gewürfelt
60 g Bacalhau (Stockfisch)
2 Tomaten, gehäutet und gewürfelt
60 g Okra, in Scheiben
1 Knoblauchzehe, gehackt
240 ml Fischbrühe
240 ml Kokosmilch
4 TL Kokosöl (Dendê)
2 EL Koriander, gehackt
4 Flusskrebsschwänze, gekocht
120 g Tintenfischringe, gekocht
4 Flusskrebse, ganz und gekocht
2 EL Limettensaft
4 EL Cashewnüsse, geröstet

4 EL Frühlingszwiebeln, gehackt
Salz, Pfeffer

Öl in einer Pfanne erhitzen und Miesmuscheln, Venusmuscheln, Shrimps, Zwiebel, Bacalhau, Tomaten, Okra und Knoblauch dazu geben. Bei hoher Temperatur für ca. 1 Minute kochen, bis sich die Muscheln beginnen zu öffnen. Mit Fischbrühe ablöschen, Kokosmilch, Kokosöl und Koriander dazu geben und für 2 bis 3 Minuten kochen. Die Flusskrebsschwänze, Tintenfischringe und die ganzen Krebse hinzufügen. Mit Limettensaft, Salz und Pfeffer abschmecken. In eine Kasserolle geben und mit Cashewnüssen und Frühlingszwiebeln garnieren.

2 c. à soupe d'huile d'olive
12 moules
12 coques
12 crevettes
1 petit oignon blanc coupé en dés
60 g de morue
2 tomates pelées et coupées en dés
60 g d'okra en lamelles
1 gousse d'ail hachée
240 ml de bouillon de poisson
240 ml de lait de noix de coco
4 c. à café de l'huile de palme (Dendê)
2 c. à soupe de coriandre hachée
4 queues d'écrevisses cuites
120 g de tronçons de seiche cuits
4 écrevisses entières et cuites
2 c. à soupe de jus de limette

4 c. à soupe de noix de cajou grillées
4 c. à soupe d'oignon de printemps haché
Sel, poivre

Mettre l'huile à chauffer dans une poêle et y mettre les moules, les coques, les crevettes, l'oignon, la morue, les tomates, l'ocra et l'ail. Faire revenir à feu vif pendant environ une minute jusqu'à ce que les moules commencent à s'ouvrir. Mouiller alors avec le bouillon de poisson, le lait de coco, l'huile de coco et ajouter la coriandre et laisser cuire 2 à 3 minutes. Ajouter les queues d'écrevisses, les morceaux de seiche et les écrevisses entières. Verser le jus de limette, saler et poivrer. Mettre dans une casserole et parsemer de noix de cajou et d'oignon haché.

2 cucharadas de aceite de oliva
12 mejillones
12 almejas
12 gambas
1 cebolla blanca pequeña, en cuadraditos
60 g de bacalao
2 tomates, pelados y en cuadraditos
60 g de okra, a rodajas
1 diente de ajo, picado
240 ml de caldo de pescado
240 ml de leche de coco
4 cucharaditas de aceite de coco (Dendê)
2 cucharadas de cilantro, picado
4 colas de cangrejos de río, cocidas
120 g de calamares, cocidos
4 cangrejos de río, enteros y cocidos
2 cucharadas de zumo de lima
4 cucharadas de nueces Cashew, tostadas

4 cucharadas de cebolletas, picadas
Sal, pimienta

Calentar el aceite en una sartén y añadir mejillones, almejas, gambas, cebolla, bacalao, tomates, okra y ajo. Cocinar a temperatura alta durante aprox. 1 minuto hasta que los mariscos empiecen a abrirse. Rebajar con el caldo de pescado, añadir la leche de coco, el aceite de coco y el cilantro y cocinar de 2 a 3 minutos. Añadir las colas de cangrejo de río, los calamares y los cangrejos enteros. Sazonar con zumo de lima, sal y pimienta. Poner en un cazo y adornar con nueces Cashew y cebolletas.

2 cucchiai di olio d'oliva
12 cozze
12 vongole
12 gamberetti
1 cipolla bianca piccola tagliata a dadini
60 g di baccalà
1 pomodori pelati e tagliati a dadini
60 g di gombo a rondelle
1 spicchio d'aglio tritato
240 ml di brodo di pesce
240 ml di latte di cocco
4 cucchiaini di olio di cocco (Dendê)
2 cucchiai di coriandolo tritato
4 code di gambero di fiume lessate
120 g di anelli di calamari lessati
4 gamberi di fiume interi e lessati
2 cucchiai di succo di limetta
4 cucchiai di anacardi tostati

4 cucchiai di cipollotto tritato
Sale, pepe

In una padella riscaldate l'olio e aggiungete cozze, vongole, gamberetti, cipolla, baccalà, pomodori, gombo e aglio. Fate cuocere a temperatura elevata per circa 1 minuto finché cozze e vongole inizieranno ad aprirsi. Versatevi il brodo di pesce, aggiungete il latte di cocco, l'olio di cocco e il coriandolo e cuocete per 2–3 minuti. Aggiungete le code di gambero di fiume, gli anelli di calamari e i gamberi di fiume interi. Insaporite con succo di limetta e correggete con sale e pepe. Mettete in una casseruola e guarnite con anacardi e cipollotto.

Sushi Wabi

Design: Amelia Hepler-Briske | Chef: Jill Barron-Rosenthall
Owners: Angela M. Hepler, Susan Traina Thompson

842 West Randolph Street | Chicago, IL 60607
Phone: +1 312 563 1224
www.sushiwabi.com
Opening hours: Mon–Fri 11:30 am to 2 pm, Sat 2 pm to 5 pm,
Wed–Sat 5 pm to midnight, Sun–Tue 5 pm to 11:30 pm.
Average price: $ 20
Cuisine: Japanese
Special features: 20-seat sushi bar, carry-out and delivery available

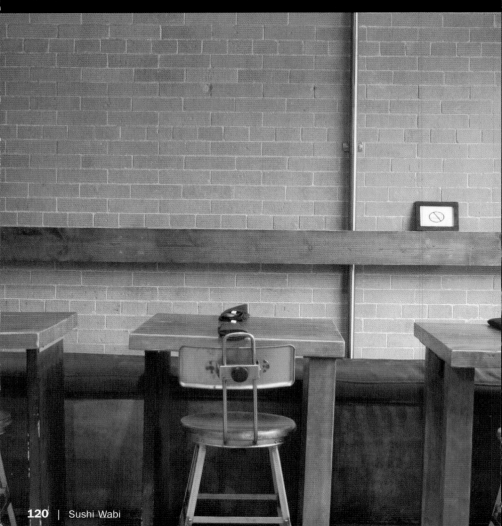

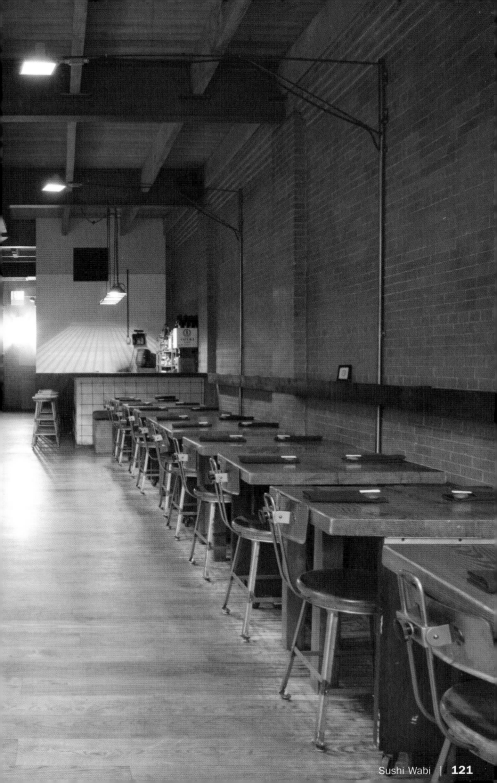

Caterpillar Maki

Raupen-Maki

Chenille de maki

Orugas Maki

Bruco Maki

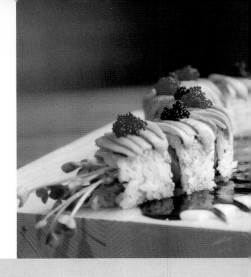

4 oz cooked sushi rice
3–4 Nori leaves (kelp)
3 tbsp Daikon sprouts (radish sprouts)
3 oz Unagi (fresh water eel)
3 oz Hamachi (yellow-fin tuna)
1 avocado, sliced
3 tbsp sesame seeds
1 tbsp red and 1 tbsp black Tobiko (fly fish roe)
Eel sauce for garnish

Spread out the sushi rice and place the kelp leaves on top. Fill with sprouts, eel and tuna and shape into a roll. Scatter with sesame seeds and cover with the avocado slices. Store in the refrigerator for 2 hours. Cut the Maki into 8 portions and arrange in the shape of a caterpillar on the plate. Garnish each portion in turn with red and black Tobiko. Serve with eel sauce.

120 g Sushi-Reis, gekocht
3–4 Blätter Nori (Seetang)
3 EL Daikonsprossen (Rettichsprossen)
90 g Unagi (Süßwasseraal)
90 g Hamachi (Gelbflossentunfisch)
1 Avocado, in Scheiben
3 EL Sesamsamen
Je 1 EL roter und schwarzer Tobiko (Fliegenfisch-rogen)
Aalsauce zum Garnieren

Sushi-Reis ausbreiten und die Seetangblätter darauf legen. Mit Sprossen, Aal und Tunfisch füllen und zu einer Rolle formen. Mit Sesamsamen bestreuen und mit Avocadoscheiben belegen. Für zwei Stunden kaltstellen. Den Maki in acht Stücke schneiden und wie eine Raupe auf einem Teller anrichten. Jedes Stück abwechselnd mit rotem und schwarzem Tobiko garnieren. Mit Aalsauce servieren.

120 g de riz à sushi cuit
3–4 feuilles de nori (algue séchée)
3 c. à soupe de pousses de radis daikon
90 g de unagi (anguille d'eau douce)
90 g de hamachi (thon albacore)
1 avocat coupé en lamelles
3 c. à soupe de graines de sésame
1 c. à soupe de tobiko rouge et 1 c. à soupe de
noir (œufs de poisson volant)
Sauce à l'anguille pour la garniture

Etaler le riz à sushi et poser les feuilles d'algues séchées dessus. Farcir avec les pousses, l'anguille et le thon et former un rouleau. Parsemer de graines de sésame et poser sur le dessus les lamelles d'avocat. Mettre au frais pendant 2 heures. Couper le maki en 8 et disposer des morceaux comme une chenille sur une assiette. Décorer chaque morceau alternativement de tobiko rouge et noir. Servir avec la sauce à l'anguille.

120 g de arroz de Sushi, cocido
3-4 hojas de Nori (alga marina)
3 cucharadas de brotes de Daikon (brotes de rábano)
90 g de unagi (anguila de agua dulce)
90 g de hamachi (atún de aletas amarillas)
1 aguacate, a rodajas
3 cucharadas de semillas de sésamo
1 cucharada de Tobiko rojo y negro respectivamente (huevas de pez volador)
Salsa de anguila para adornar

Extender el arroz de Sushi y colocar encima las hojas de las algas marinas. Rellenar con los brotes, la anguila y el atún y formar un rollo. Espolvorear las semillas de sésamo y cubrir con las rodajas de aguacate. Poner a enfriar durante 2 horas. Cortar el Maki en 8 trozos y colocar en el plato como una oruga. Adornar cada pedazo alternando un Tobiko rojo y uno negro. Servir con la salsa de angula.

120 g di riso per sushi lessato
3–4 fogli di nori (alga)
3 cucchiai di germogli di daikon (germogli di ravanello)
90 g di unagi (anguilla d'acqua dolce)
90 g di hamachi (tonno pinna gialla)
1 avocado a fette
3 cucchiai di semi di sesamo
1 cucchiaio di tobiko (uova di pesce volante) rosso e 1 di tobiko nero
Salsa all'anguilla per guarnire

Allargate il riso per sushi e adagiatevi sopra i fogli di alga. Farcite con germogli, anguilla e tonno e formate un rotolo. Cospargete di semi di sesamo e ricoprite con fette di avocado. Mettete a raffreddare per 2 ore. Tagliate il Maki in 8 pezzi e disponeteli a forma di bruco su un piatto. Guarnite ogni pezzo alternatamente con tobiko rosso e nero. Servite con salsa di anguilla.

Tizi Melloul

Design: Suhail Design Studio | Chef: Airon Adams, Jared Wentworth
Owners: Steven Ford, Quay Tao
531 North Wells Street | Chicago, IL 60610
Phone: +1 312 670 4338
www.tizimelloul.com
Opening hours: Mon–Wed 5:30 pm to 10 pm, Thu 5 pm to 10 pm,
Fri–Sat 5 pm to 11 pm, Sun 5 pm to 10 pm
Average price: $ 35
Cuisine: Mediterranean, Moroccan
Special features: Dome-shaped Crescent Room can be rented for private parties,
belly dancer on Sundays

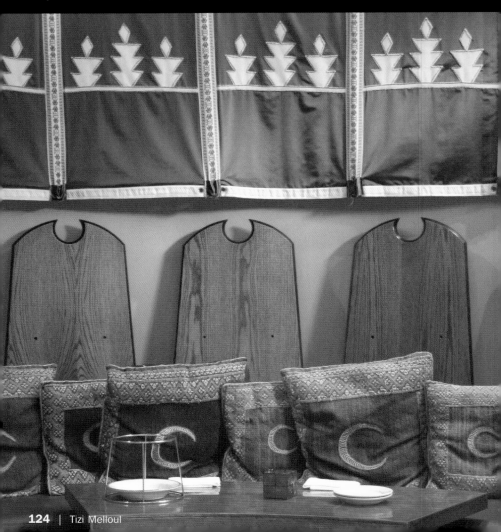

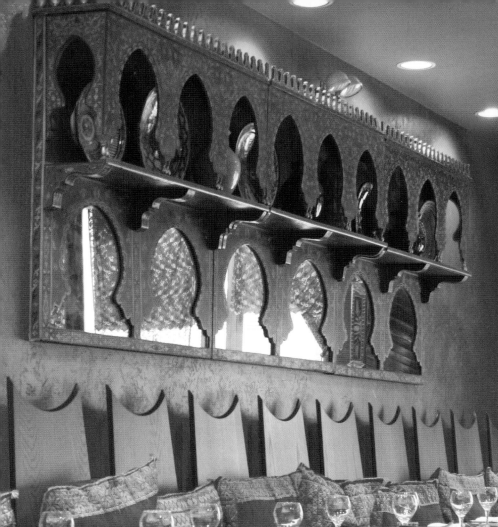

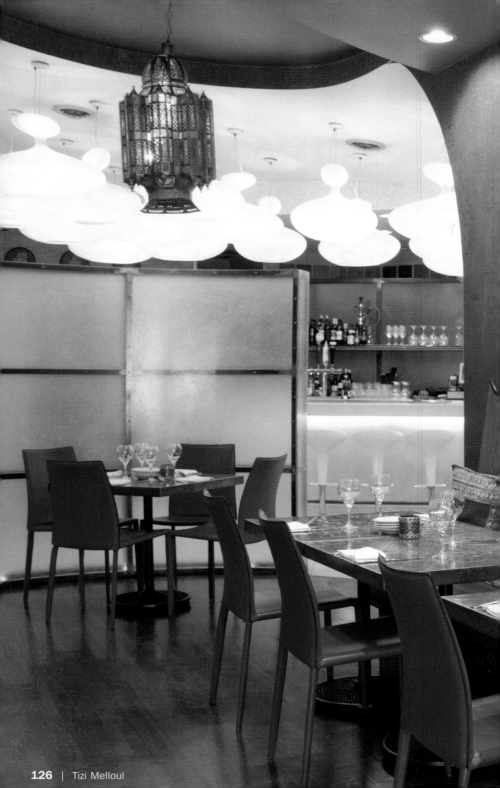

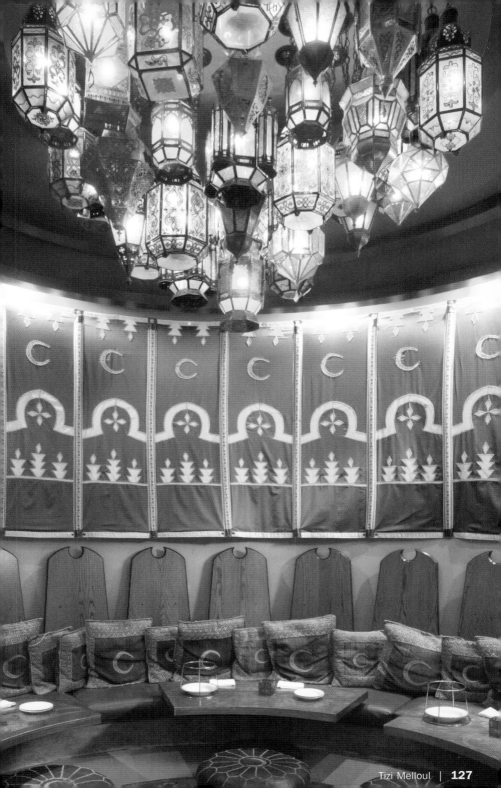

Braised Leg of Lamb

with Chana-Dal Lentils and Olives

Geschmorte Lammkeulen mit
Chana-Dal-Linsen und Oliven

Gigots de mouton rôti aux lentilles
chana-dal et aux olives

Patas de cordero asadas con lentejas
Chana Dal y olivas

Cosciotti di agnello stufati con lenticchie
Chana Dal e olive

4 legs of lamb
Salt and pepper
3 tbsp olive oil
2 garlic cloves
3 star anise
1 tbsp dried, whole cloves
1 bunch rosemary
1 bottle red wine
1 large can whole tomatoes
Cornstarch

Season the legs of lamb with salt and pepper
and lightly fry in hot oil. Add the garlic, star anise,
cloves and rosemary. Pour in the wine, reduce the
liquid by half and cover with the tomatoes. Set in
an oven at 350 °F and allow to bake for 2 hours,
until the meat is tender. Drain the juice though a
sieve, if necessary, thicken with cornstarch and
keep warm.

10 1/2 oz Chana Dal lentils
1 l cream
24 roasted garlic cloves
4 oz stoneless Kalamata olives
4 tbsp freshly chopped herbs (parsley, chives,
rosemary)
Salt and pepper
2 tbsp butter

Place all ingredients in a saucepan and cook until
the lentils are soft and covered with the cream.
Season with salt, pepper and butter. Pour the
lentils onto a soup dish, place the leg of lamb on
top and sprinkle with the lamb juices.

4 Lammkeulen
Salz, Pfeffer
3 EL Olivenöl
2 Knoblauchzehen
3 Sternanis
1 EL getrocknete ganze Nelken
1 Bund Rosmarin
1 Flasche Rotwein
1 große Dose ganze Tomaten
Speisestärke

Die Keulen mit Salz und Pfeffer würzen und
in heißem Öl anbraten. Knoblauch, Sternanis,
Nelken und Rosmarin zugeben. Wein eingießen,
um die Hälfte reduzieren und mit den Tomaten
bedecken. Bei 180 °C in den Ofen schieben und
2 Stunden garen lassen, bis das Fleisch weich
ist. Jus durch ein Sieb gießen, falls nötig mit
Speisestärke abdicken und warmstellen.

300 g Chana-Dal-Linsen
1 l Sahne
24 geröstete Knoblauchzehen
120 g entsteinte Kalamata-Oliven
4 EL frisch gehackte Kräuter (Petersilie, Schnitt-
lauch, Rosmarin)
Salz, Pfeffer
2 EL Butter

Alle Zutaten in einen Topf geben und so lange
kochen, bis die Linsen weich und mit Sahne über-
zogen sind. Mit Salz, Pfeffer und Butter abschme-
cken. Linsen in einen Suppenteller geben, die
Lammkeule darauf setzen und mit der Lammjus
beträufeln.

4 gigots de mouton
Sel, poivre
3 c. à soupe d'huile d'olive
2 gousses d'ail
3 étoiles de badiane
1 c. à soupe de clous de girofle entiers et séchés
1 bouquet de romarin
1 bouteille de vin rouge
1 grosse boîte de tomates entières
1 maïzena

Saler et poivrer les gigots et les faire revenir dans l'huile bien chaude. Ajouter l'ail, l'anis étoilé, les clous de girofle et le romarin. Verser le vin, le faire réduire de moitié, ouvrir ensuite avec des tomates. Mettre au four à 180 °C et laisser cuire 2 heures jusqu'à ce que la viande soit tendre. Passer le jus, l'épaissir avec la maïzena si nécessaire et le tenir au chaud.

300 g de lentilles indiennes chana-dal
1 l de crème
24 gousses d'ail rôties
120 g d'olives Kalamata dénoyautées
4 c. à soupe de fines herbes (persil, ciboulette, romarin)
Sel, poivre
2 c. à soupe de beurre

Mettre tous les ingrédients dans une casserole et laisser sur le feu jusqu'à ce que les lentilles soient cuites et qu'elles soient recouvertes de crème. Saler et poivrer et ajouter le beurre. Mettre les lentilles dans une assiette à soupe, poser le gigot dessus et arroser de jus de viande.

4 patas de cordero
Sal, pimienta
3 cucharadas de aceite de oliva
2 dientes de ajo
3 piezas de anís estrellado
1 cucharada de clavos enteros secos
1 manojo de romero
1 botella de vino tinto
1 lata grande de tomates enteros
Fécula para espesar

Sazonar las patas con sal y pimienta y freír en aceite caliente. Añadir el ajo, el anís estrellado, los clavos y el romero. Echar el vino, rebajar a la mitad y cubrir con los tomates. Poner al horno a 180 °C y cocer durante 2 horas hasta que la carne esté tierna. Verter el jugo por un colador, si es necesario espesar con fécula y mantener caliente.

300 g de lentejas Chana Dal
1 l de nata
24 dientes de ajo tostados
120 g de olivas Kalamata sin hueso
4 cucharadas de hierbas recién cortadas (perejil, cebollino, romero)
Sal, pimienta
2 cucharadas de mantequilla

Poner todos los ingredientes en una olla y cocinar hasta que las lentejas estén tiernas y cubiertas de nata. Sazonar con sal, pimienta y mantequilla. Poner las lentejas en un plato hondo, colocar encima la pata de cordero y rociar con el jugo del cordero.

4 cosciotti di agnello
Sale, pepe
3 cucchiai di olio d'oliva
2 spicchi d'aglio
3 anici stellati
1 cucchiaio di chiodi di garofano essiccati e interi
1 mazzetto di rosmarino
1 bottiglia di vino rosso
1 barattolo grande di pomodori interi
Amido di mais

Salate e pepate i cosciotti di agnello e fateli rosolare in olio bollente. Aggiungete aglio, anice stellato, chiodi di garofano e rosmarino. Versate il vino, fate ridurre della metà e coprite con i pomodori. Mettete in forno a 180 °C e fate cuocere 2 ore finché la carne sarà tenera. Passate il sugo in un colino, se necessario, addensatelo con amido di mais e mettete in caldo.

300 g di lenticchie Chana Dal
1 l di panna
24 spicchi d'aglio tostati
120 g di olive Kalamata snocciolate
4 cucchiai di erbe appena tritate (prezzemolo, erba cipollina, rosmarino)
Sale, pepe
2 cucchiai di burro

Mettete tutti gli ingredienti in una pentola e fateli cuocere finché le lenticchie saranno tenere e ricoperte di panna. Correggete con sale e pepe e insaporite con burro. Mettete le lenticchie in un piatto fondo, sovrapponetevi il cosciotto di agnello e versatevi alcune gocce di sugo di agnello.

Zest Restaurant

Design: Studio GAIA | Chef: Joshua Young

525 North Michigan Avenue | Chicago, IL 60611
Phone: +1 312 321 8766
www.chicago.intercontinental.com
Opening hours: Mon–Thu 6 am to 10 pm, Fri 6 am to 10:30 pm,
Sat 7 am to 10:30 pm, Sun 7 am to 10 pm
Average price: $ 20
Cuisine: New American with Mediterranean influence
Special features: Upstairs dining room can be rented out for private parties

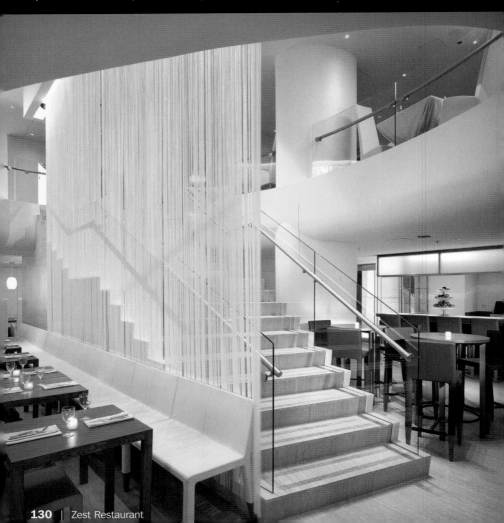

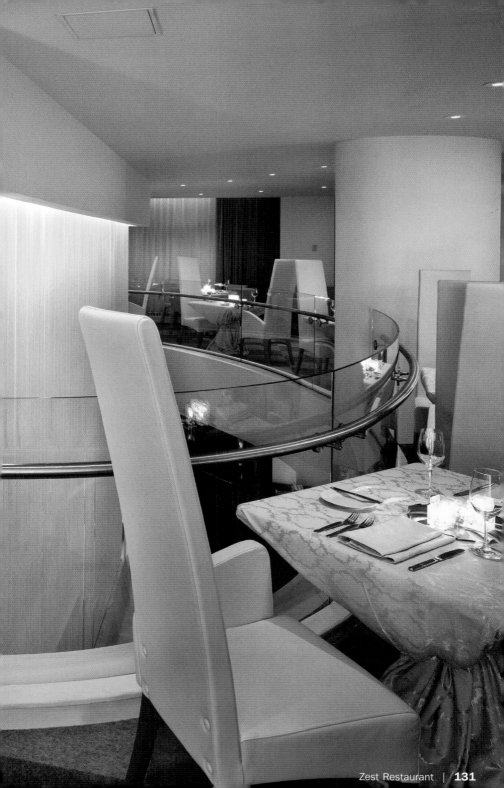

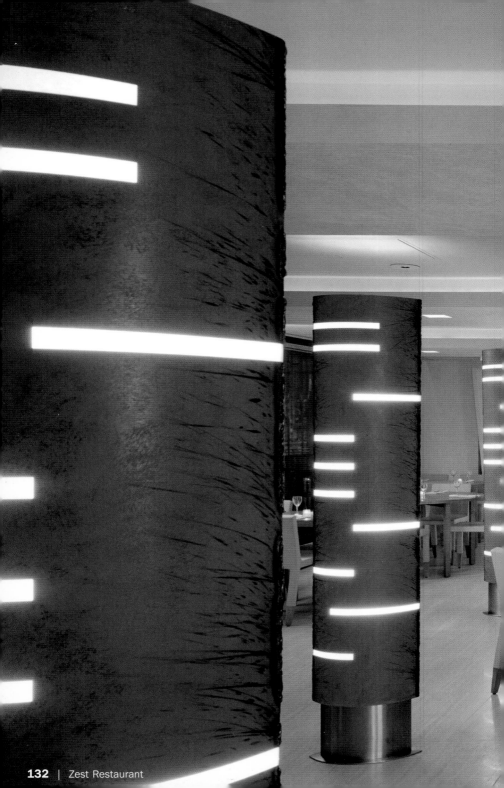

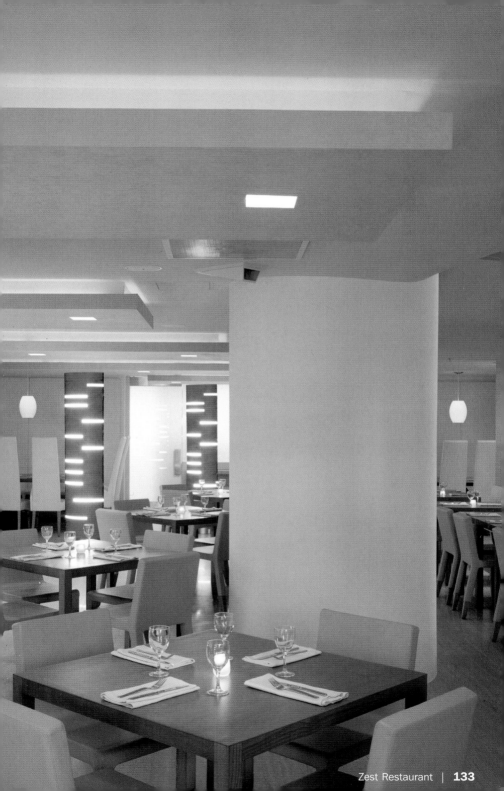

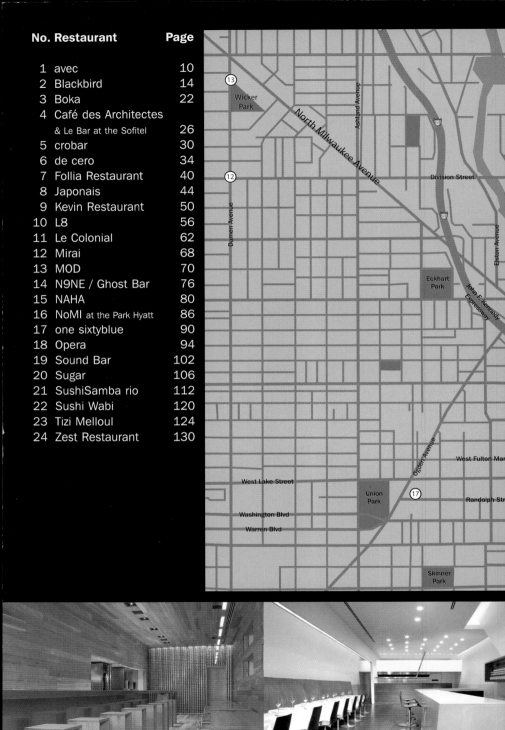

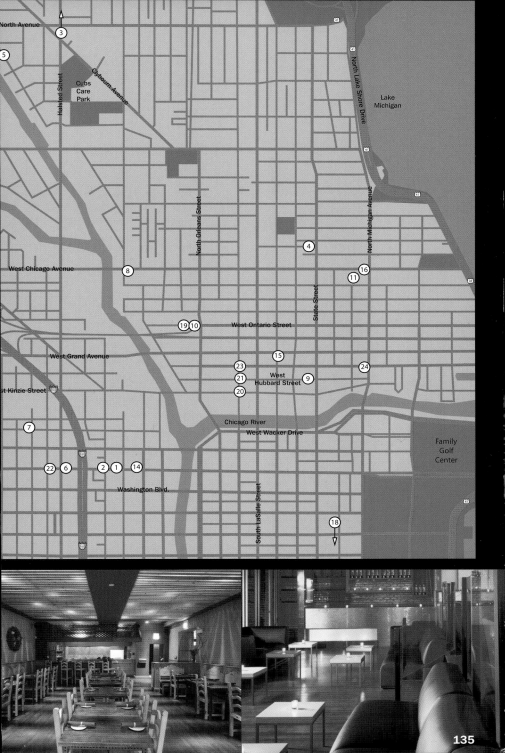

Cool Restaurants

Size: 14 x 21.5 cm / 5 $\frac{1}{2}$ x 8 $\frac{1}{2}$ in.
136 pp
Flexicover
c. 130 color photographs
Text in English, German, French,
Spanish and (*) Italian

Other titles in the same series:

Amsterdam (*)
ISBN 3-8238-4588-8

Barcelona (*)
ISBN 3-8238-4586-1

Berlin (*)
ISBN 3-8238-4585-3

Côte d'Azur (*)
ISBN 3-8327-9040-3

Hamburg (*)
ISBN 3-8238-4599-3

London
ISBN 3-8238-4568-3

Los Angeles (*)
ISBN 3-8238-4589-6

Madrid
ISBN 3-8327-9029-2

Milan (*)
ISBN 3-8238-4587-X

Munich (*)
ISBN 3-8327-9019-5

New York
ISBN 3-8238-4571-3

Paris
ISBN 3-8238-4570-5

Rome (*)
ISBN 3-8327-9028-4

Shanghai (*)
ISBN 3-8327-9050-0

Sydney (*)
ISBN 3-8327-9027-6

Tokyo (*)
ISBN 3-8238-4590-X

Vienna (*)
ISBN 3-8327-9020-9

**To be published in the
same series:**

Brussels Miami
Cape Town Moscow
Geneva Stockholm
Hong Kong Zurich

teNeues